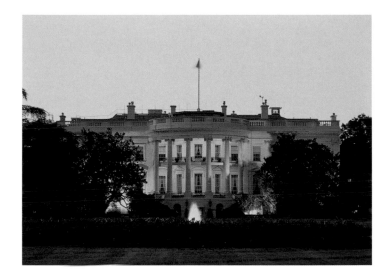

WASHINGTON D.C.

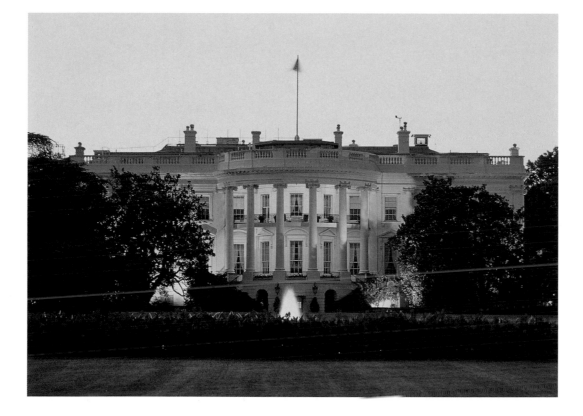

WHITECAP BOOKS
VANCOUVER / TORONTO / NEW YORK

Text by Tanya Lloyd
Edited by Elaine Jones
Photo editing by Tanya Lloyd
Proofread by Lisa Collins
Cover and interior design by Steve Penner
Printed and bound in Canada

Canadian Cataloguing in Publication Data

Lloyd, Tanya, 1973–

 Washington D.C.

 (America series)
 ISBN 1-55285-112-5

 1. Washington (D.C.)—Pictorial works. I. Title. II. Series: Lloyd, Tanya,
1973- America series.
F195.L66 2000 975.3'041'0222 C00-0911067-4

The publisher acknowledges the support of the Canada Council and the Cultural
Services Branch of the Government of British Columbia in making this publication
possible. We acknowledge the financial support of the Government of Canada through
the Book Publishing Industry Development Program for our publishing activities.

For more information on the America Series and other Whitecap Books
titles, please visit our web site at www.whitecap.ca.

In the halls of the Capitol, officials are molding the future of the nation. Senators vote on reforms, lobbyists press their positions, reporters jot notes on the latest news. Downtown restaurants bustle with politicians debating the current issues. In the neighborhoods of Washington, D.C., however, the future is not the first thing that comes to mind. In some ways, the entire metropolitan area is a museum of America's past.

Strolling the mall, sightseers might come face-to-face with a 19-foot sculpture of President Jefferson. They might wander amid the soldiers of the Korean War or recite the Declaration of Independence from within the National Archives. Even outside the city center, monuments honor the past. Christ Church, where George Washington purchased a family pew, still caters to the residents of Alexandria, Virginia. In nearby Arlington, visitors pay tribute to the graves of the Kennedys.

Among these ever-present reminders of the past, the Washington of the present flourishes. The bustling city center is home to more than 640,000 people, and another 3 million live in the surrounding areas. Commuters pack Pennsylvania Avenue each evening, nature lovers flock to the paths and trails of Rock Creek Park, and thousands turn out for the annual Fourth of July celebrations.

For both residents and visitors, the combination of past, present, and future sparks constant excitement. New experiences are just around the corner—and in Washington, that corner is likely to contain a reminder of the city's rich history.

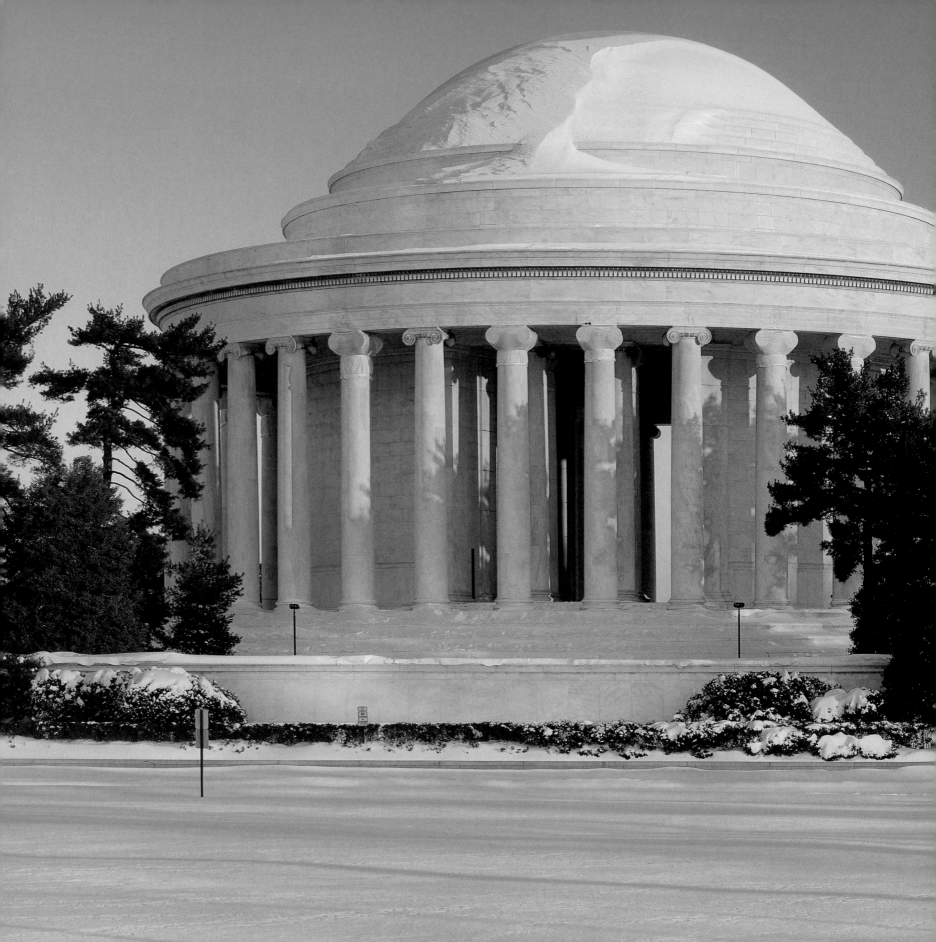

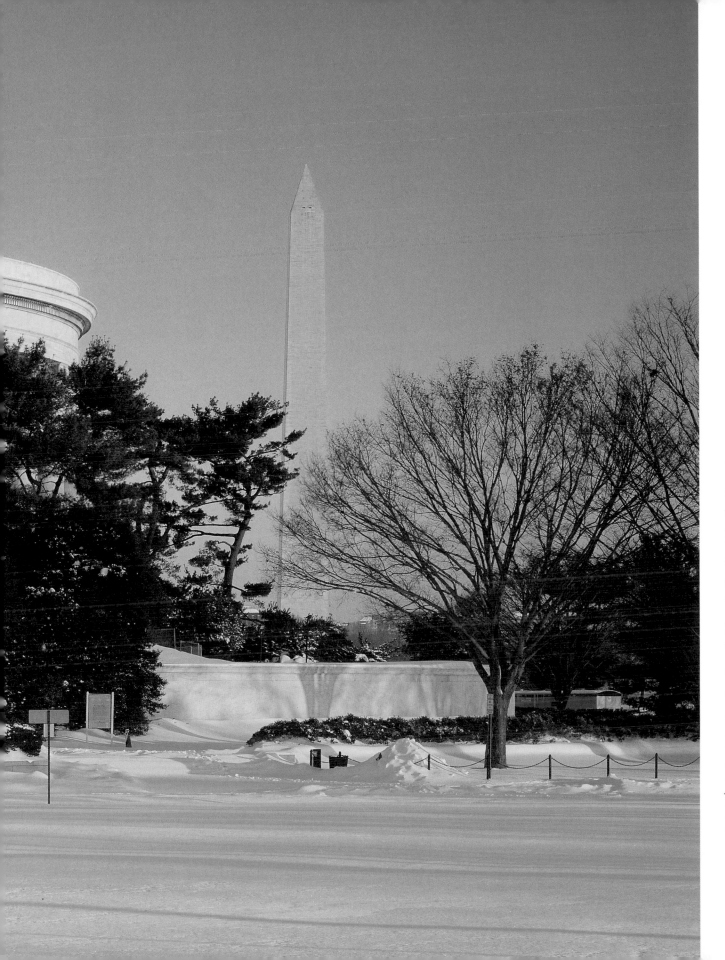

The Jefferson Memorial, pictured here with the Washington Monument behind, commemorates the achievements of Thomas Jefferson, third president of the United States. The white marble rotunda with its 26 columns was based on Rome's Pantheon, a design that inspired Jefferson when he planned the University of Virginia.

7

The statue of Thomas Jefferson stands 19 feet tall within the Jefferson Memorial. It is surrounded by excerpts from his writings, including the Declaration of Independence.

FACING PAGE—
The government of the United States had operated from Washington for only 14 years when the city was captured and burned by British soldiers during the war of 1812. American forces reclaimed and rebuilt the city.

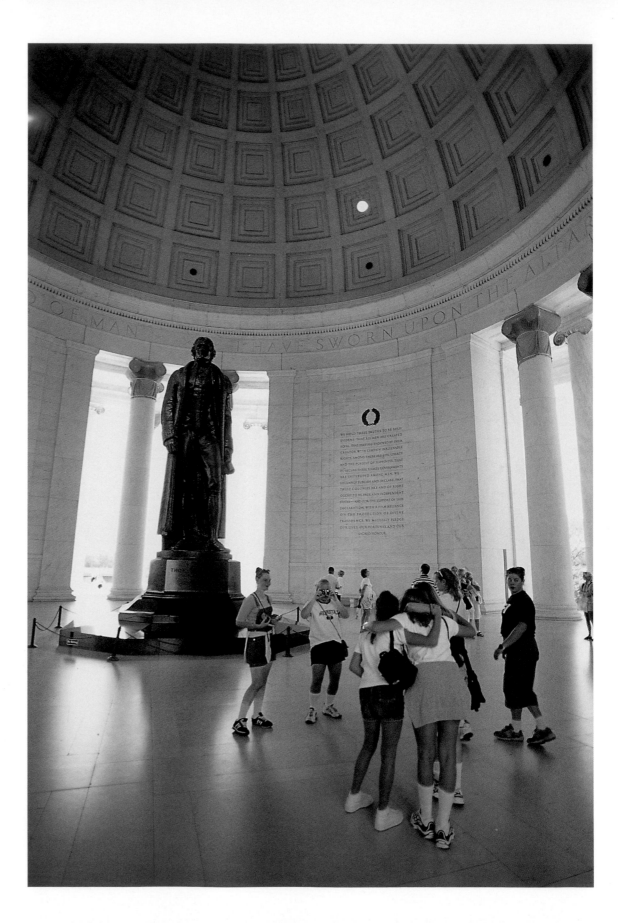

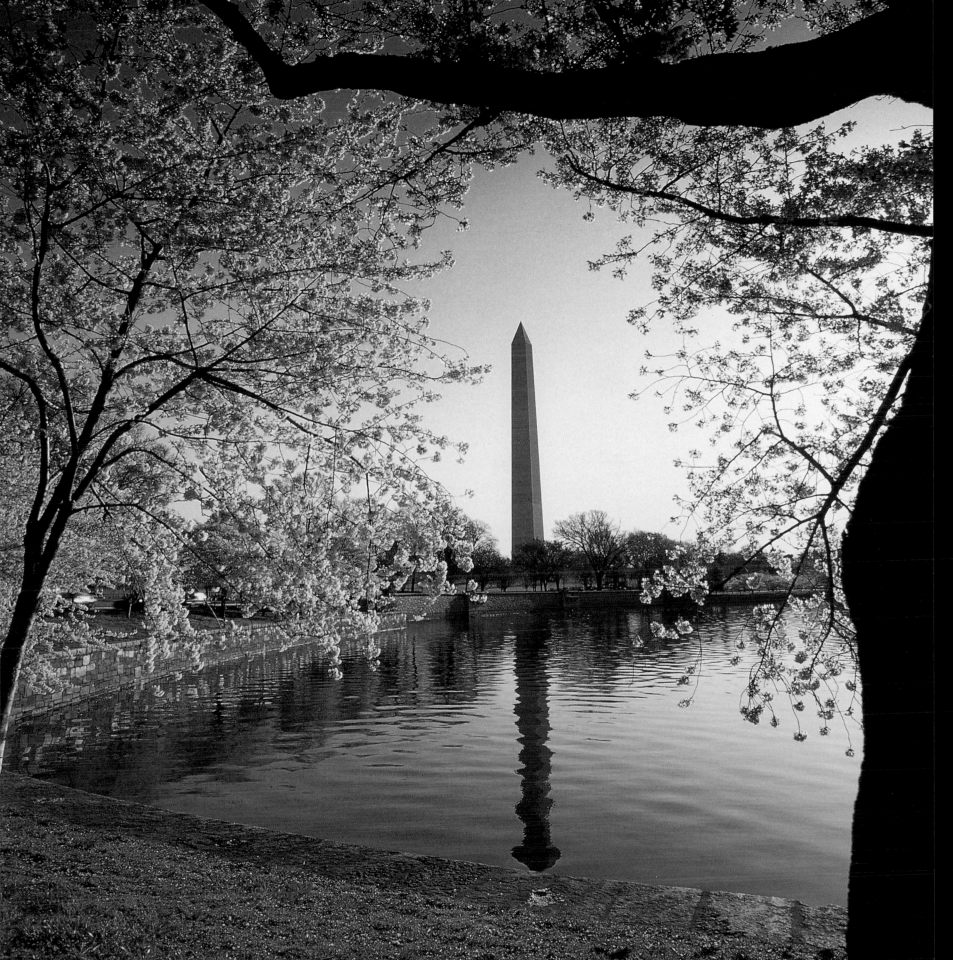

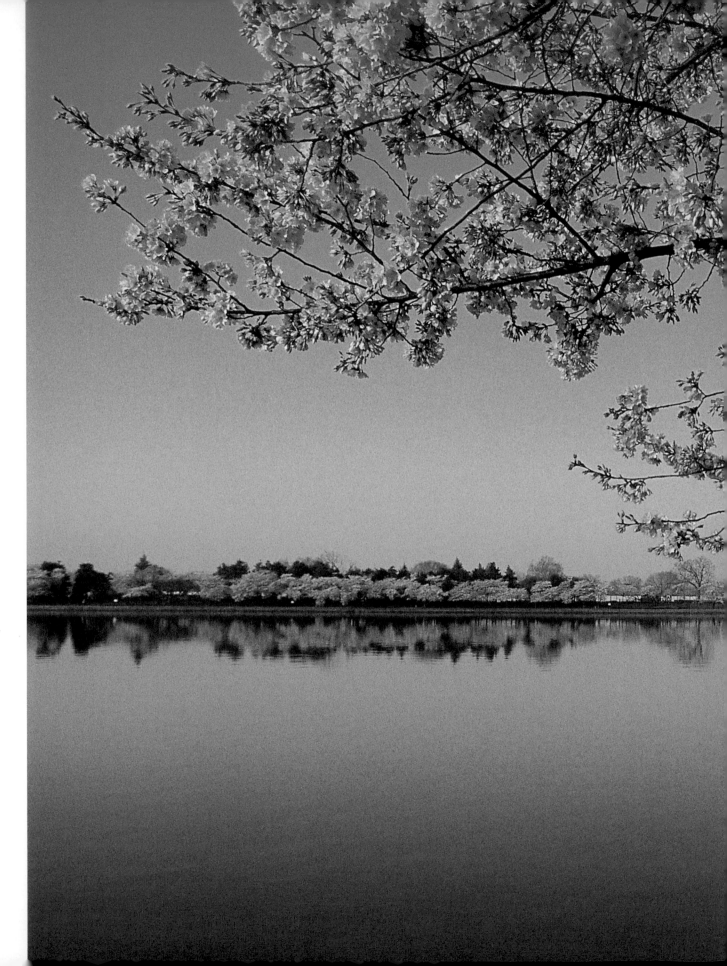

The Tidal Basin, originally designed as a water reservoir, is one of Washington's favorite recreation sites. Spring, when 1,300 cherry trees that line the banks burst into bloom, is the best time to visit.

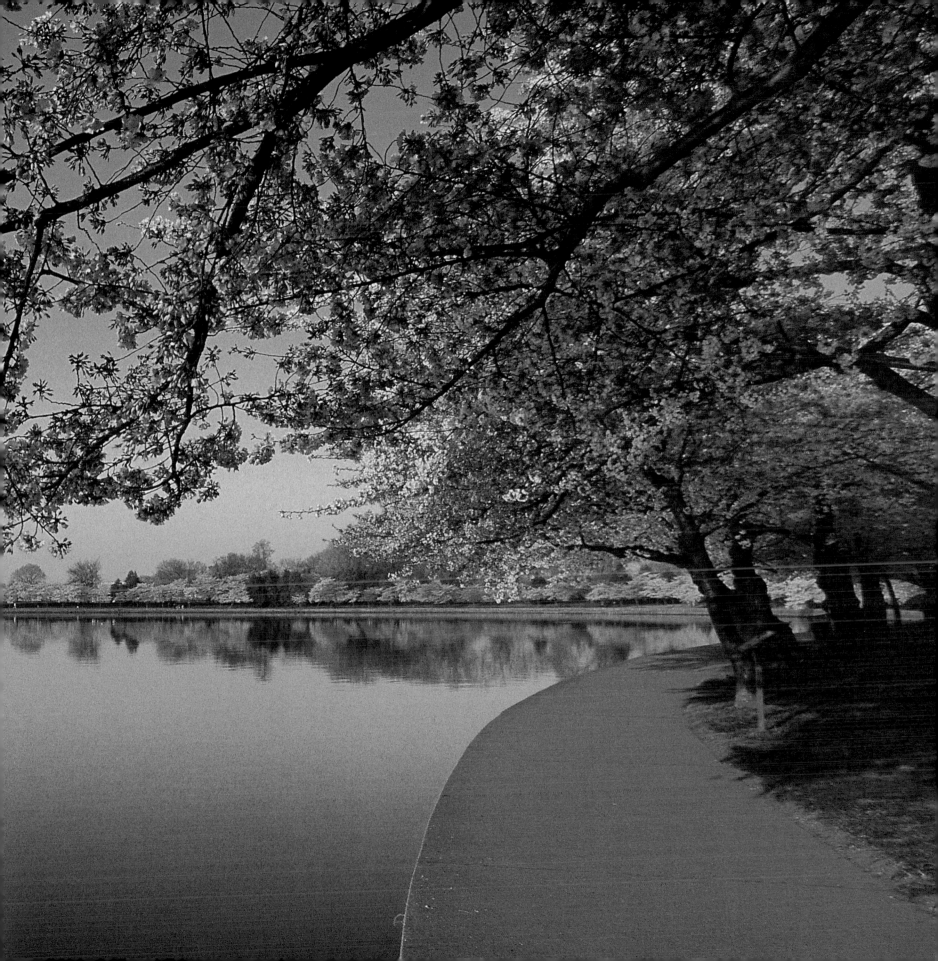

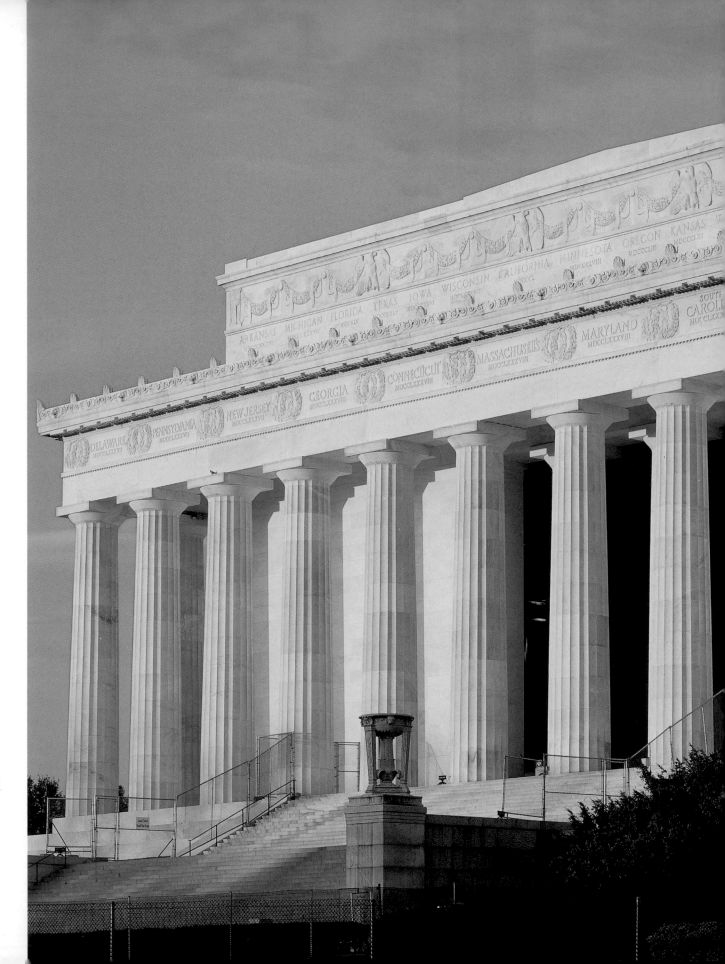

A symbol of the tragedies of the Civil War, the victory of liberty, and the personal achievements of President Abraham Lincoln, the Lincoln Memorial was dedicated on May 30, 1922.

12

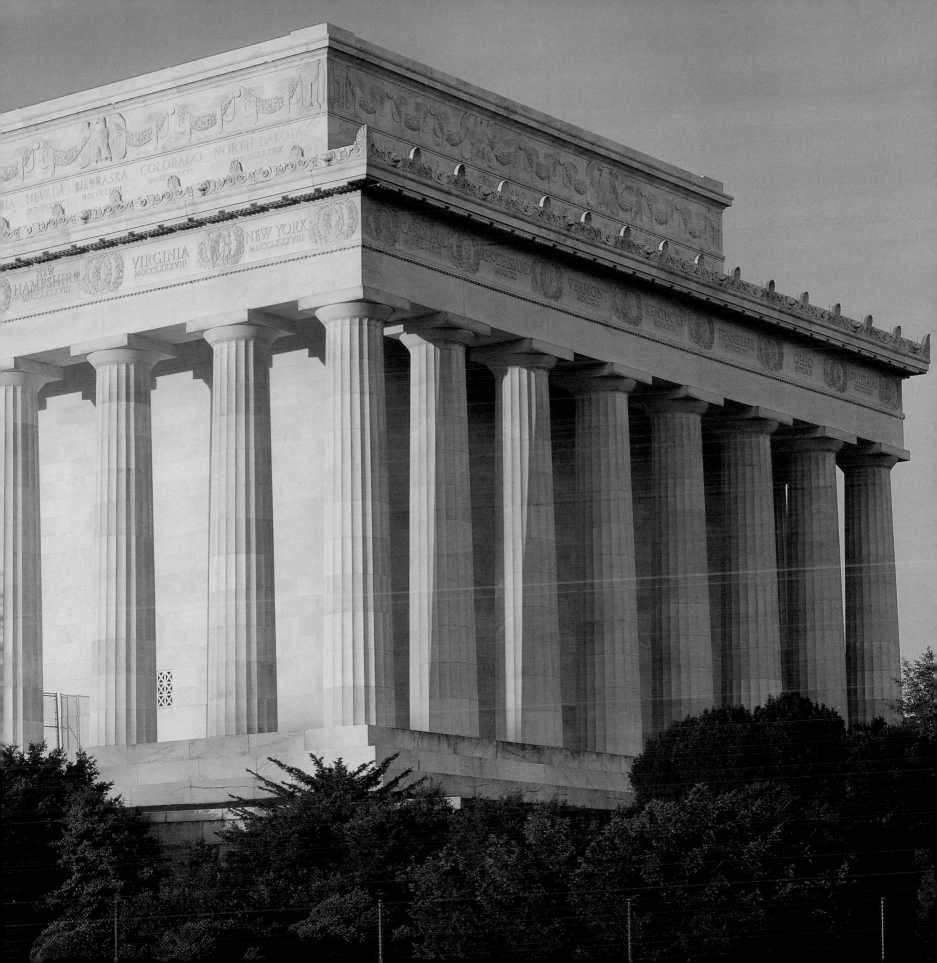

Daniel Chester French carved the statue of the sixteenth president for the interior of the Lincoln Memorial. The sculptor strove to show both Lincoln's determination and his compassion, the characteristics for which he is best remembered. The words of Lincoln's most famous speeches are inscribed on the surrounding walls.

FACING PAGE— America's capital celebrates the Fourth of July like nowhere else. On the last centennial— July 4, 1976—33 tons of fireworks burst over the city. The July 4 date commemorates the signing of the Declaration of Independence in 1776.

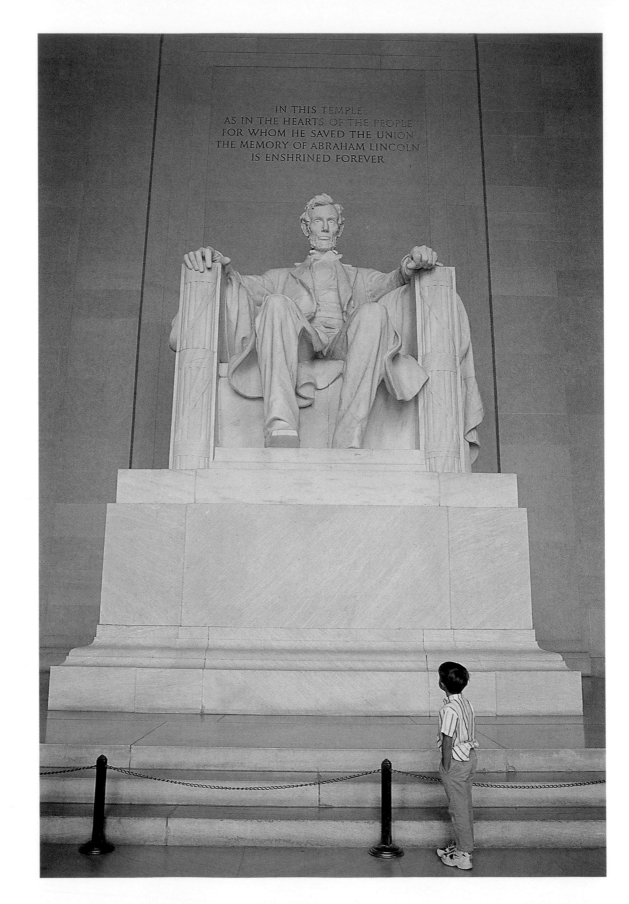

IN THIS TEMPLE
AS IN THE HEARTS OF THE PEOPLE
FOR WHOM HE SAVED THE UNION
THE MEMORY OF ABRAHAM LINCOLN
IS ENSHRINED FOREVER

14

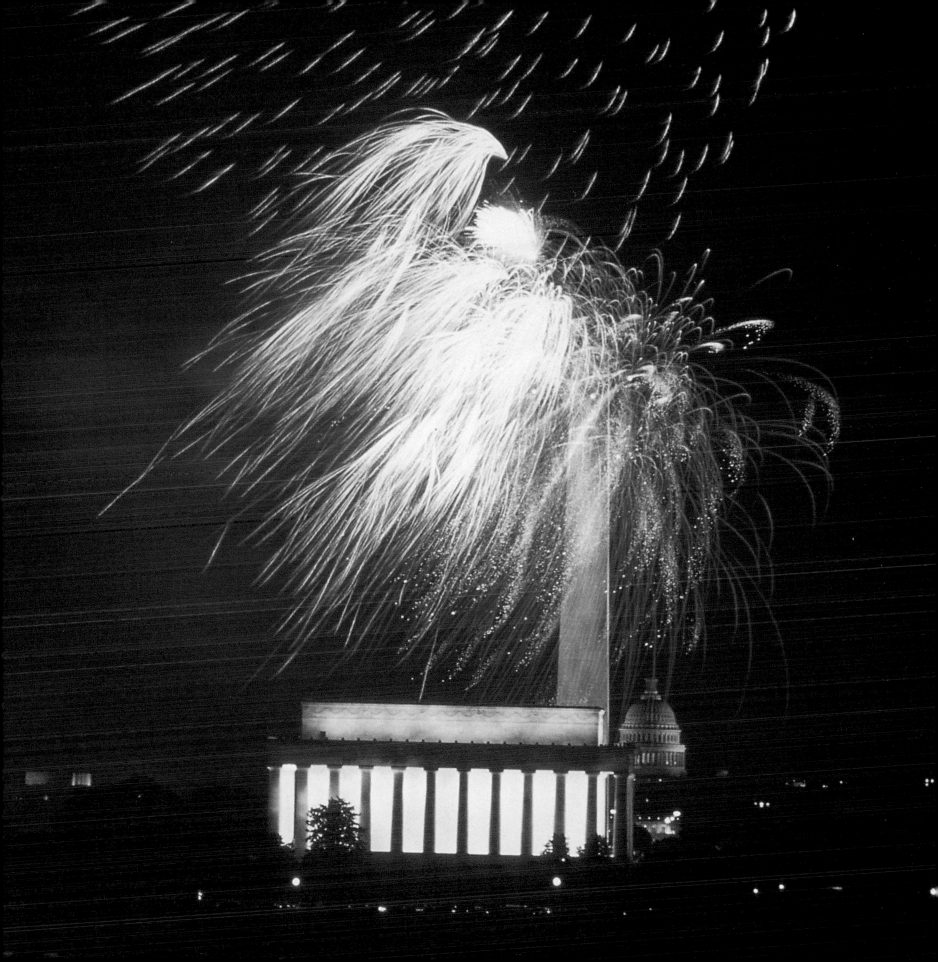

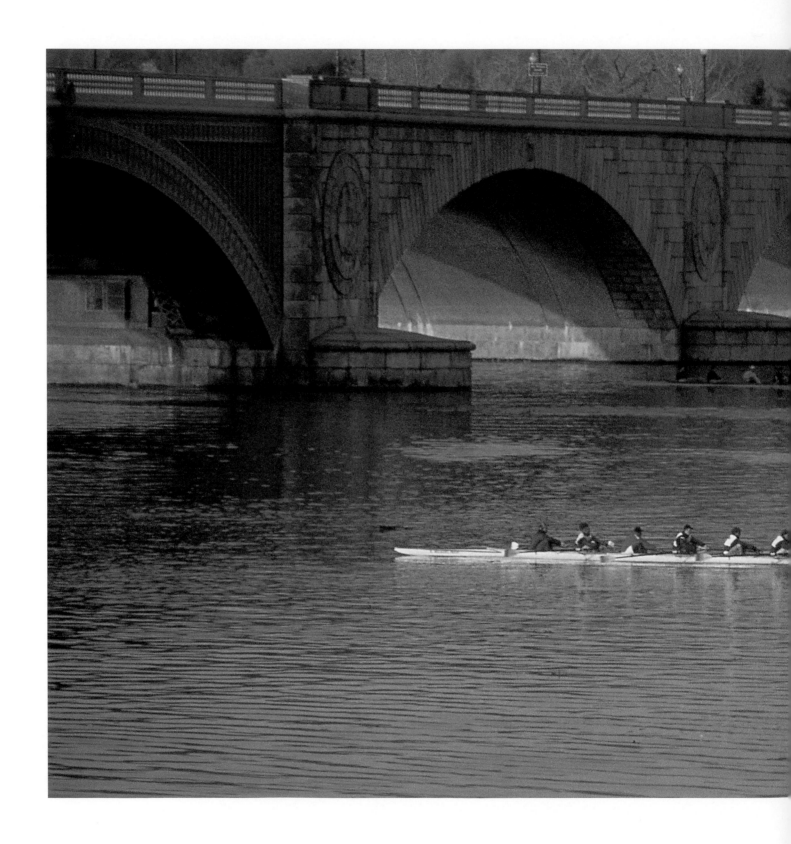

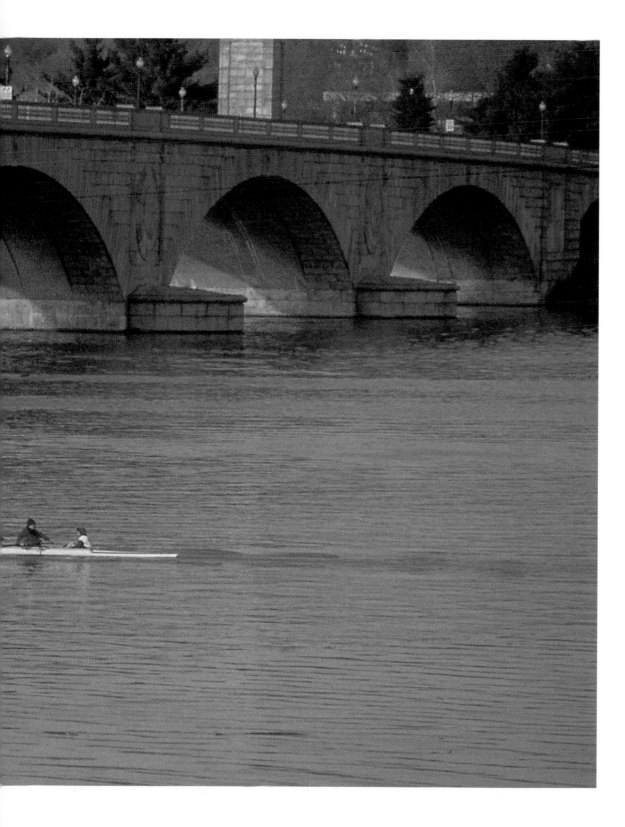

The Potomac River flows 285 miles from Cumberland, Maryland to Chesapeake Bay. The Potomac Boat Club hosts annual regattas on the scenic waterway, and local teams can often be spotted practicing on the calm, early morning waters.

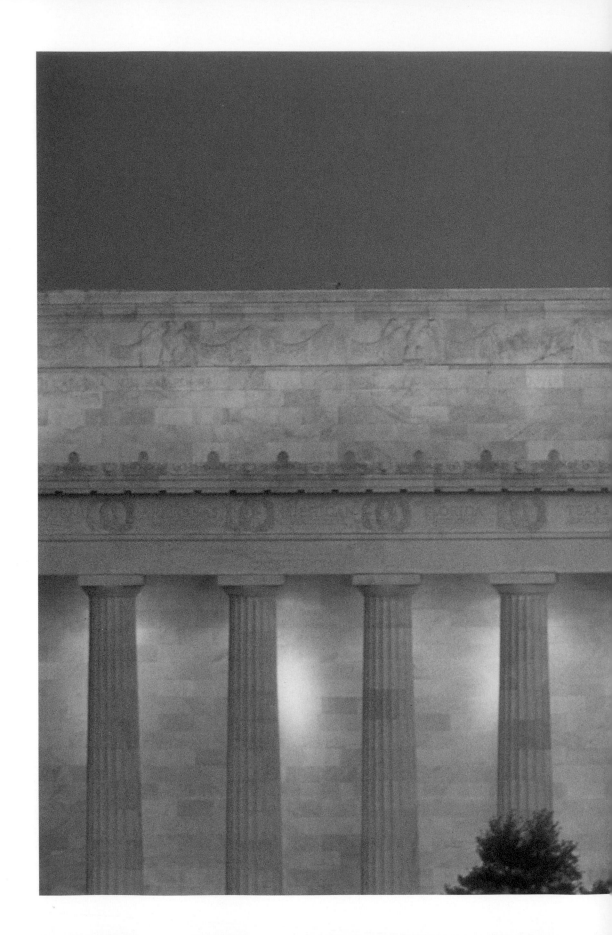

The 100-square-mile site near the center of the original 13 colonies was personally selected by George Washington for the capital of his newborn nation. The government was transferred here in 1800.

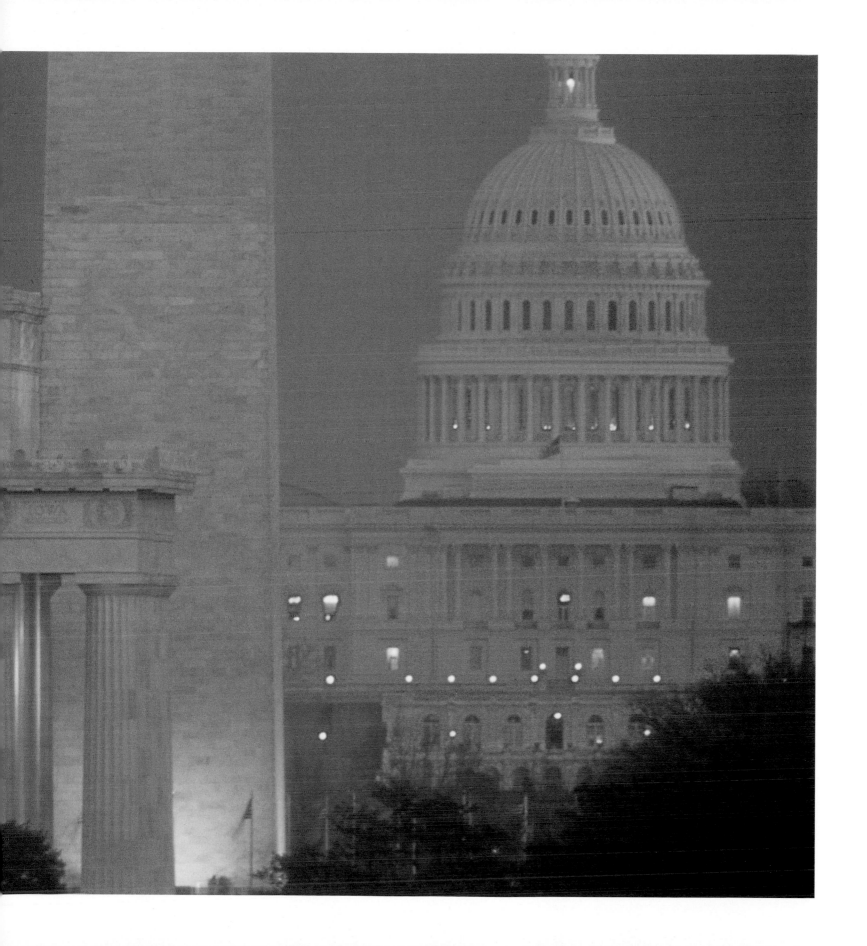

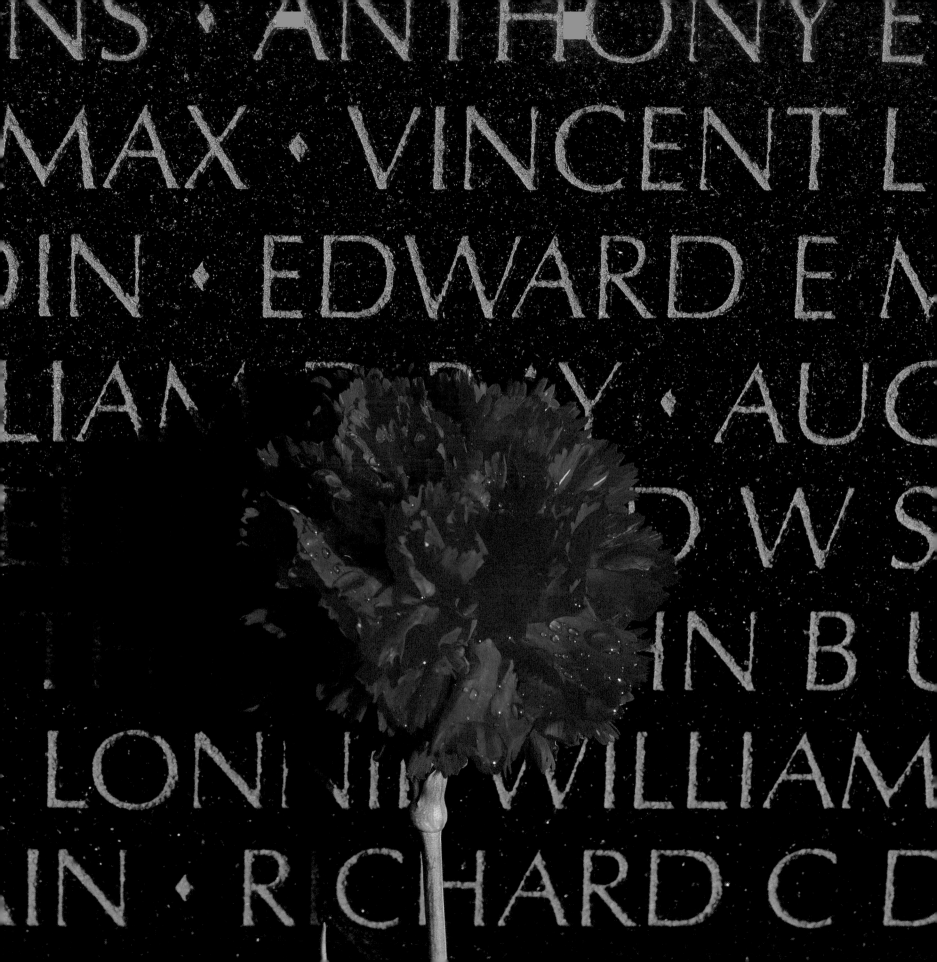

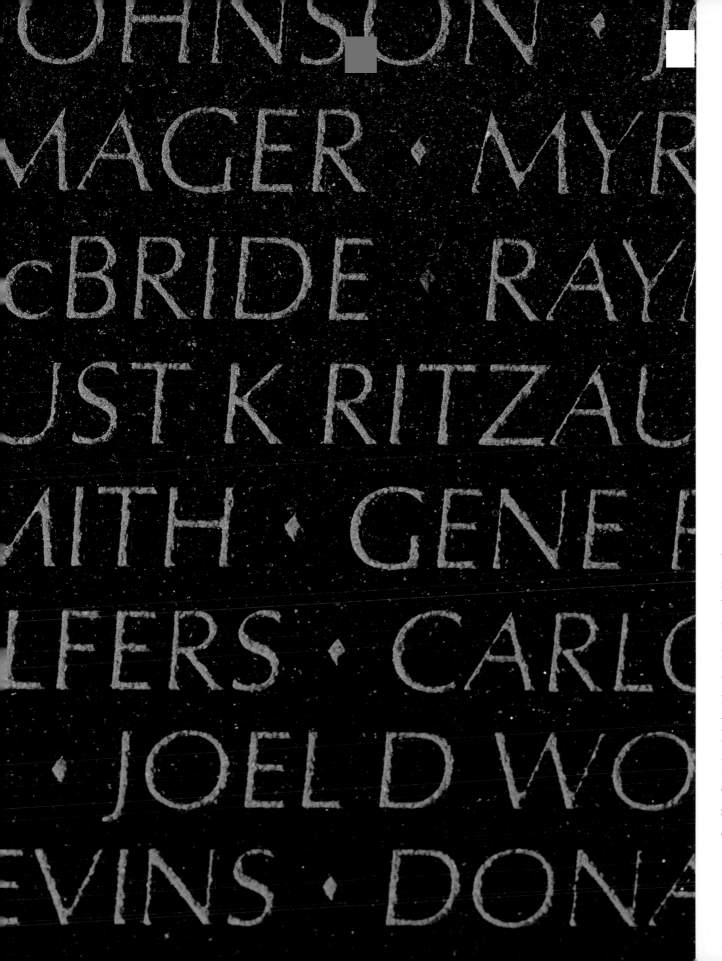

When Congress authorized the Vietnam Veterans Memorial in 1980, more than 1,400 candidates submitted ideas. Twenty-one-year-old Yale architecture student Maya Lin won the contest with her stark granite wall of veterans' names.

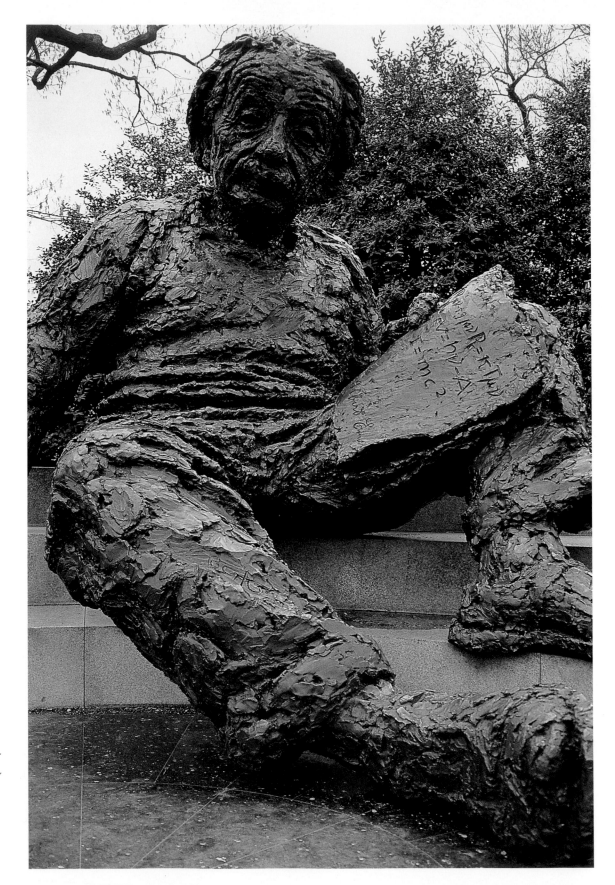

Created by Robert Berks, this statue of Albert Einstein stands before the National Academy of Sciences. The Academy serves as an advisory body to the government. It was established in 1863 to investigate, examine, experiment, and report upon any subject of concern.

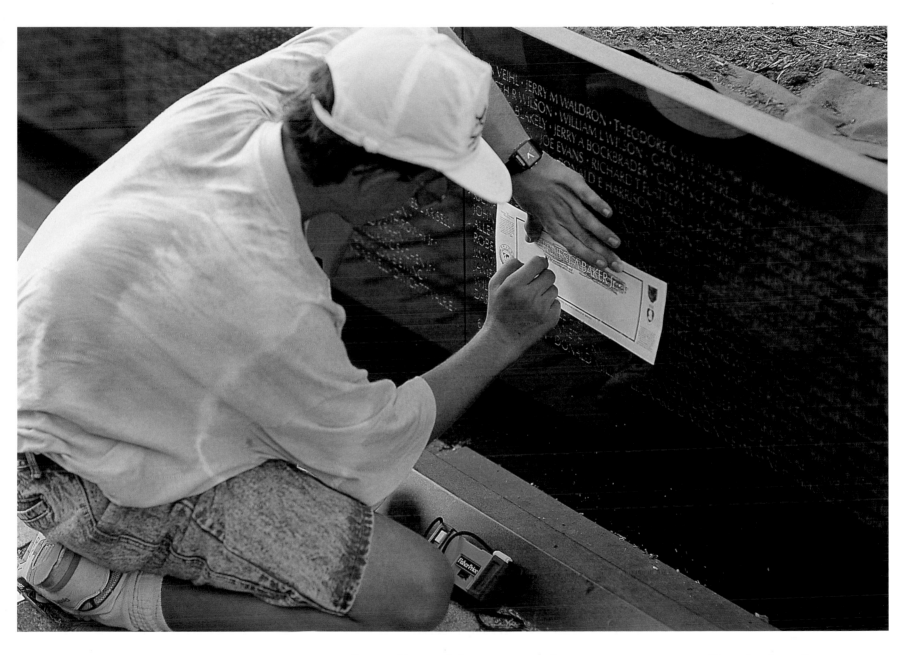

Regardless of their views about government policy during the Vietnam War, visitors to the memorial honor those who fought, sometimes taking rubbings of relatives' names from among the more than 57,000 inscribed on the wall.

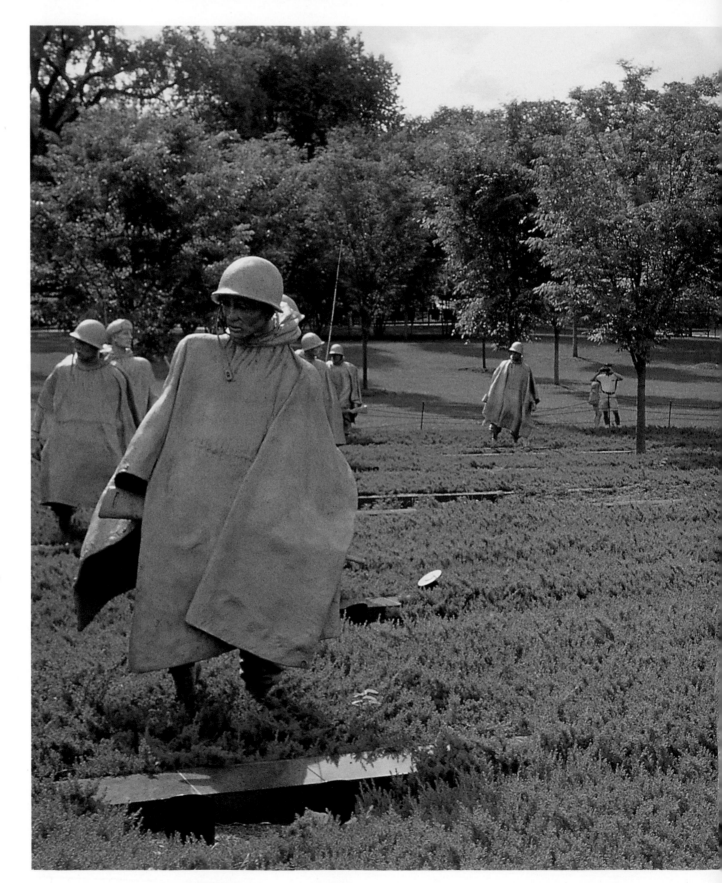

Featuring sculptures by Frank C. Gaylord, the Korean War Veterans Memorial honors those who died in the 1950–1954 conflict. George Bush broke ground for the memorial in 1992. It was dedicated on July 27, 1995.

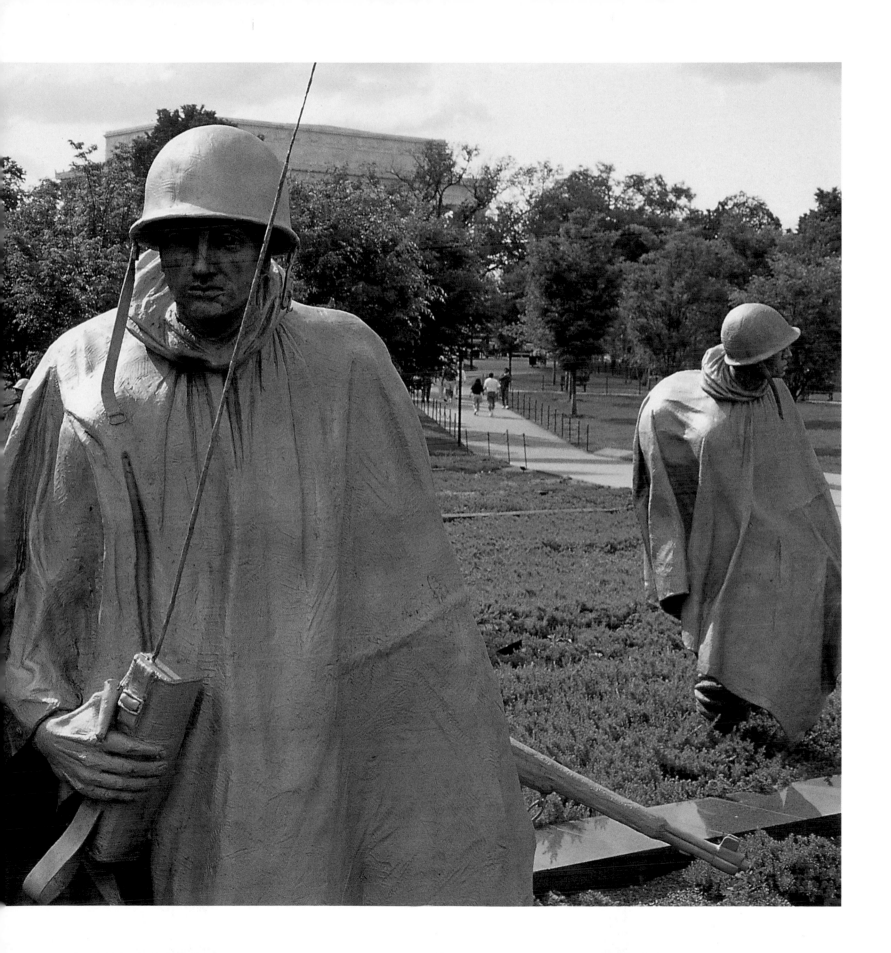

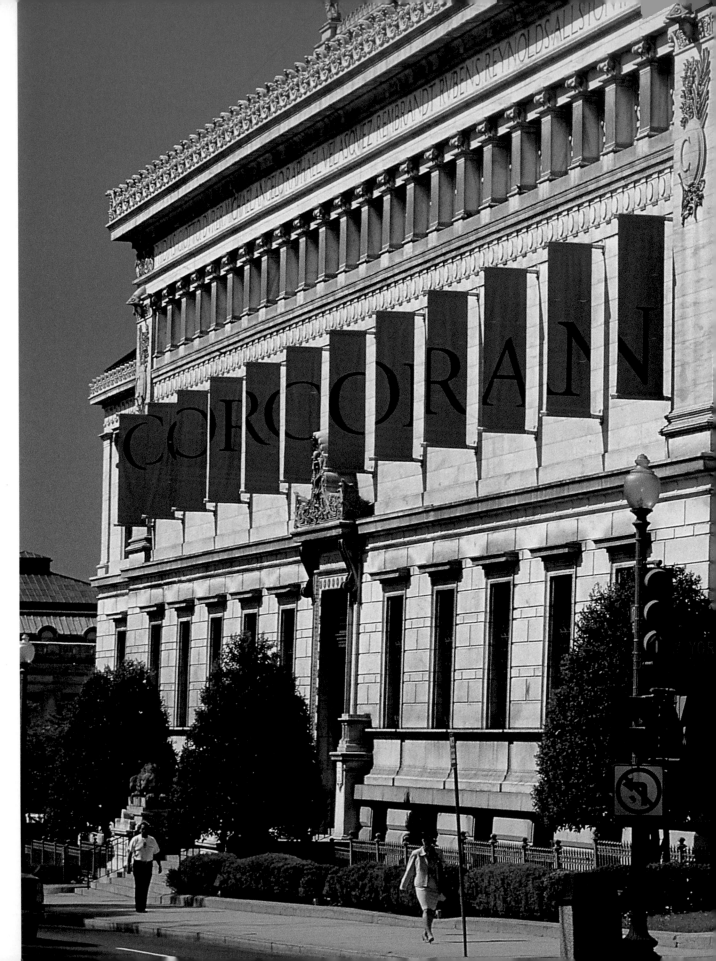

Washington's first art gallery, the Corcoran, was founded in 1874 and moved to its present Beaux Arts–style building in 1897. From eighteenth-century portraits to the experimental work of Andy Warhol, the gallery showcases the best of American art.

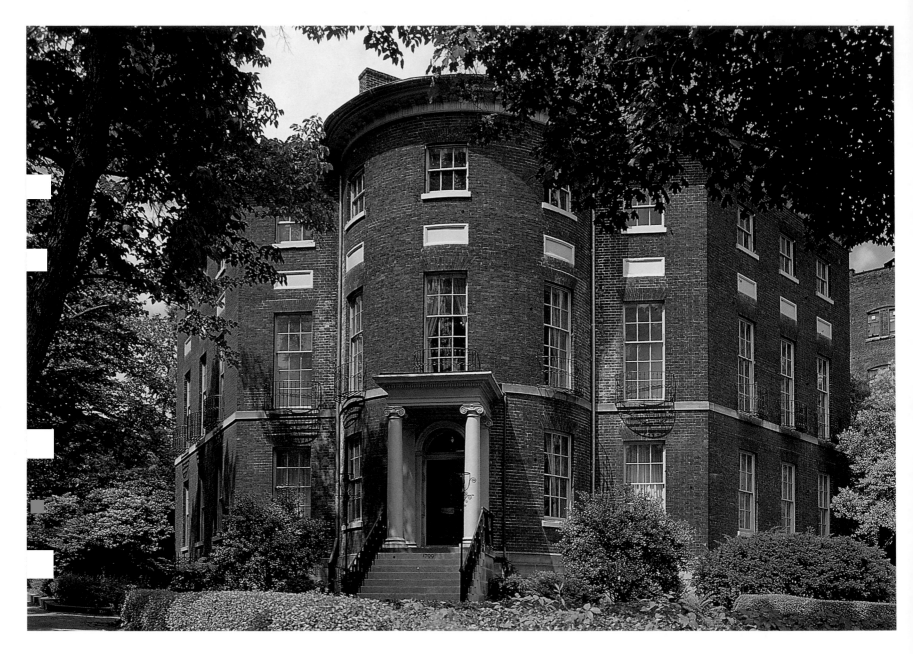

When the British burned the White House in 1814, President
Madison took refuge at the Octagon House, signing the Treaty
of Ghent in the parlor on the second floor. The home now serves
as the Museum of the American Architectural Foundation.

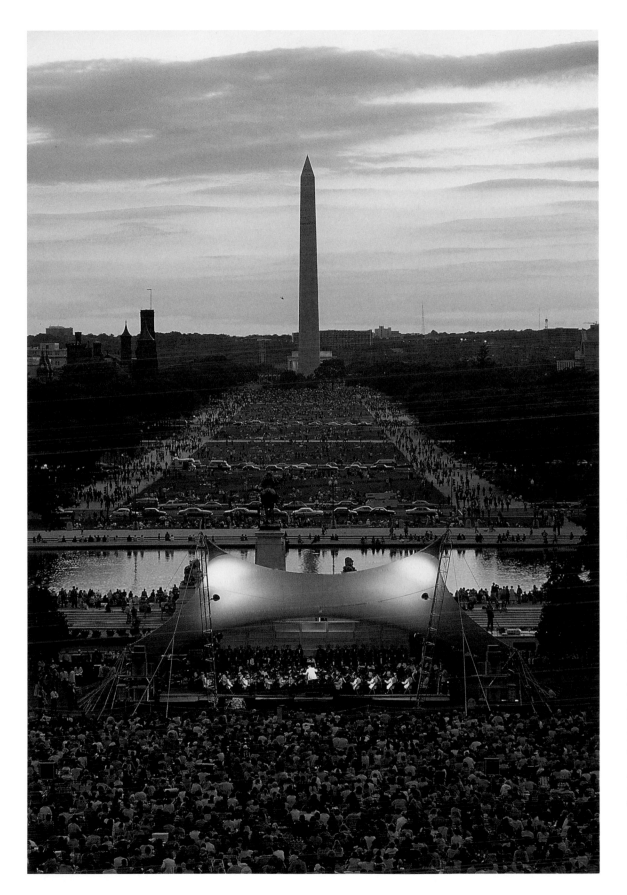

Music enthusiasts gather for an outdoor concert by the Washington Symphony Orchestra. Regular performances by the orchestra at the DAR Constitution Hall draw more than 3,500 fans, making this one of Washington's most popular cultural organizations.

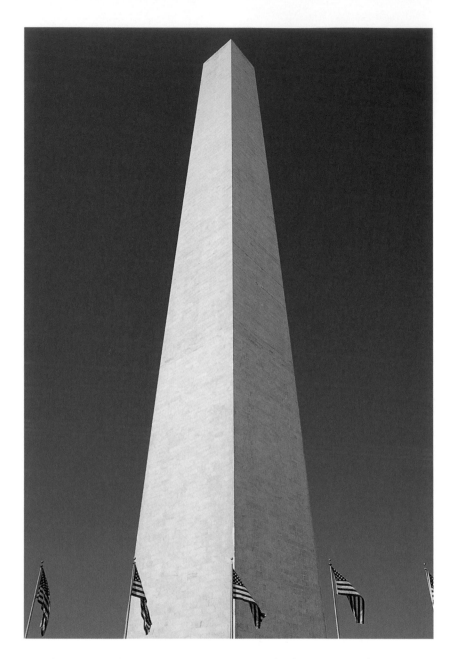

Built to symbolize the power and elegance of George Washington, the Washington Monument's 555-foot marble obelisk towers over the city. The capstone alone weighs 3,300 pounds.

Home to the presidents of the United States since John Adams, 1600 Pennsylvania Avenue—the White House—was designed by James Hoban in 1792. It remained the largest home in the nation until after the Civil War.

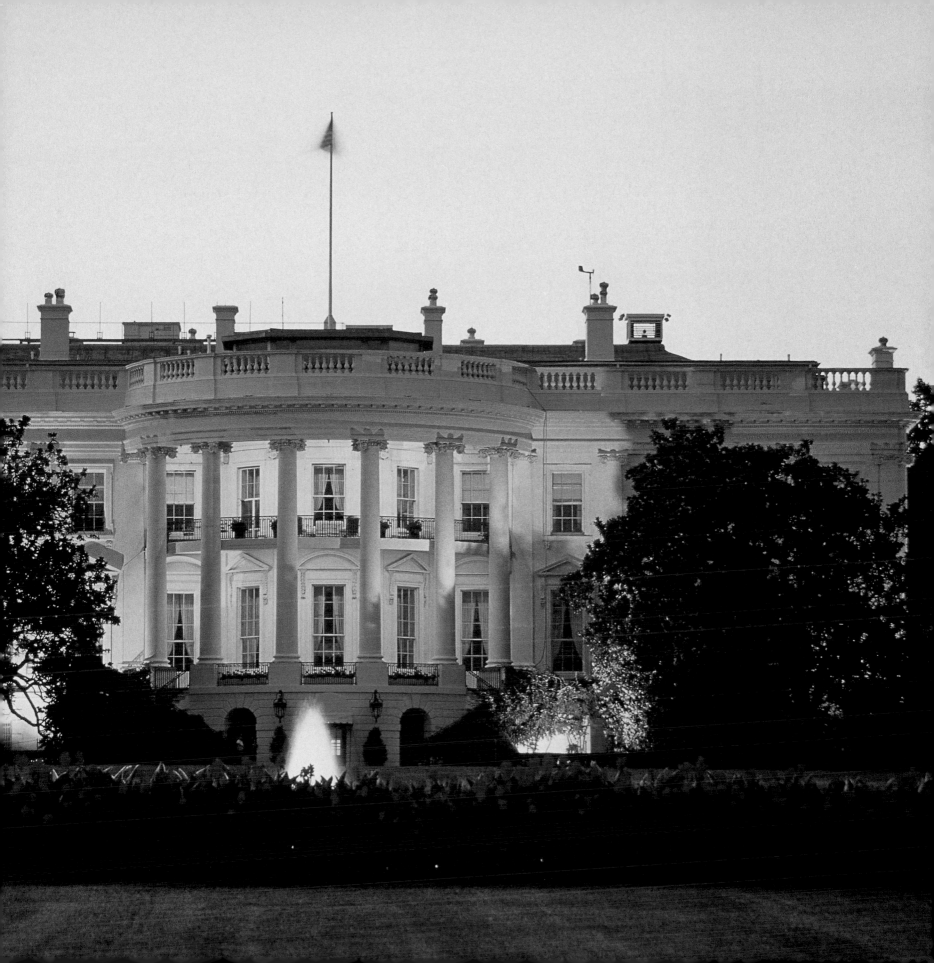

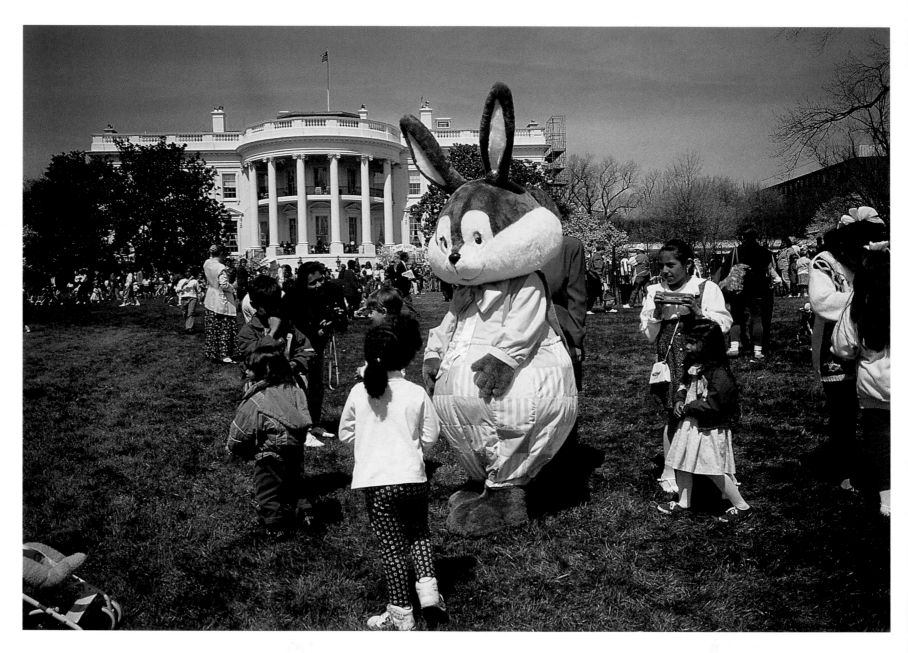

The White House chef and his staff dye almost 10,000 eggs for
the annual Easter egg roll, an event that attracts more than
27,000 guests to the lawns of the White House. President Andrew
Johnson's family began the tradition.

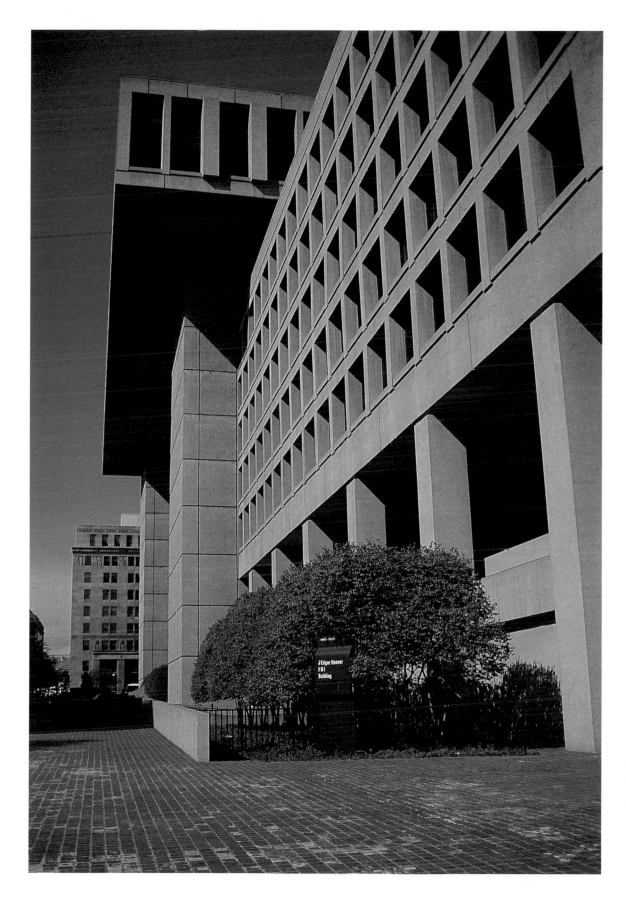

On a tour of the
FBI Building, visitors
observe the agency's
crime labs, study
a list of the top 10
most-wanted crim-
inals, and watch an
agent demonstrate
sharp-shooting skills.
About 500,000 sight-
seers take the tour
each year.

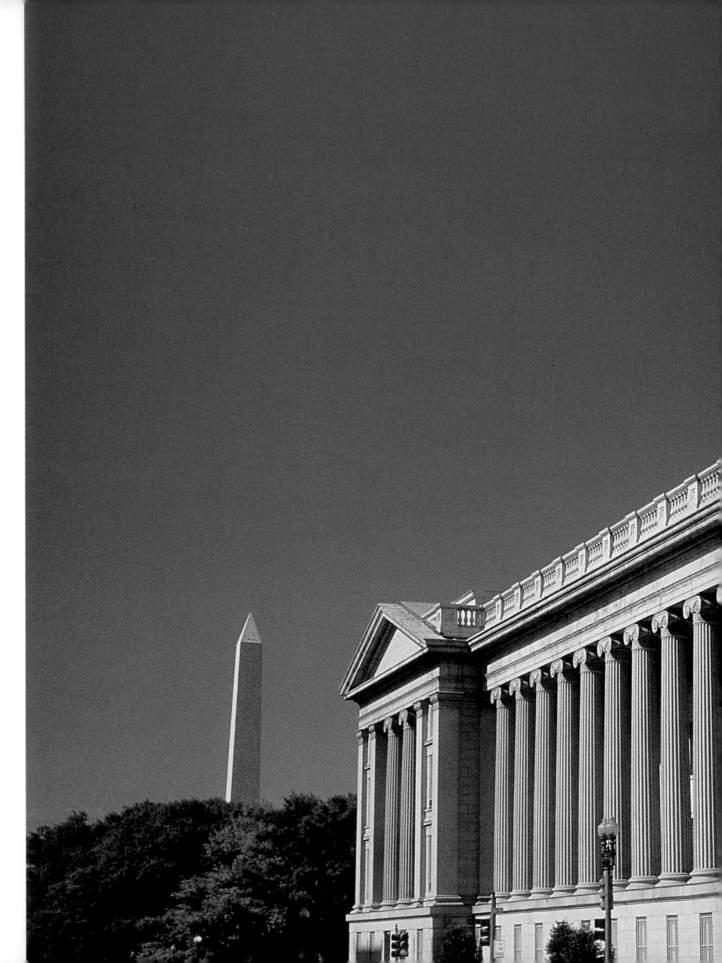

The Main Treasury
Building stands on
Pennsylvania Avenue
directly between the
White House and the
Capitol. Pundits
speculate that when
relations between
President Andrew
Jackson and Con-
gress deteriorated,
the president ordered
the Treasury Build-
ing placed where it
would block his
view of the Capitol.

34

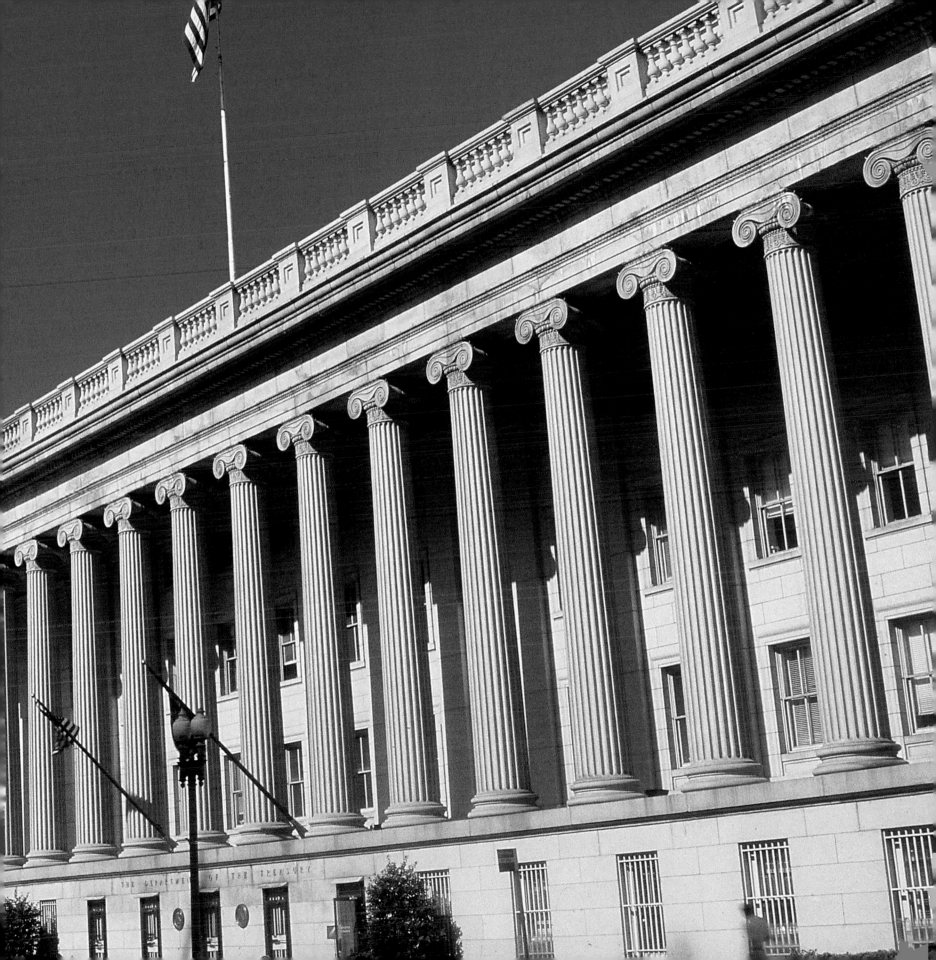

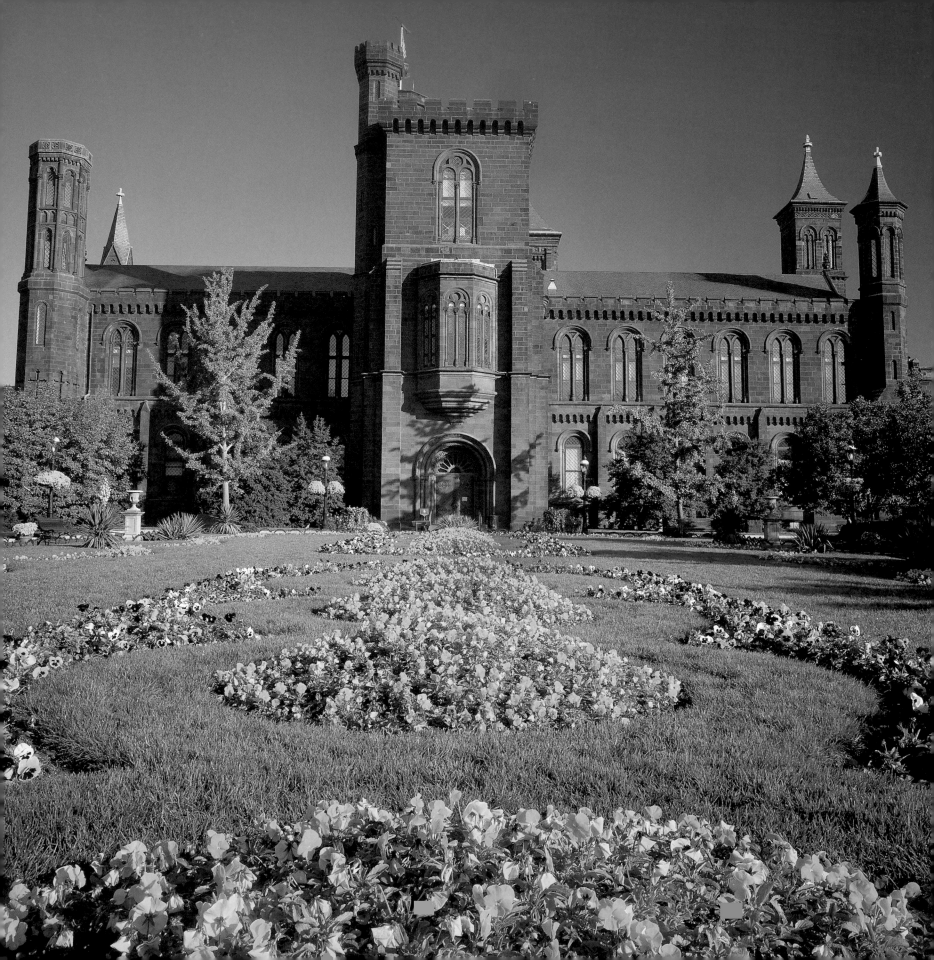

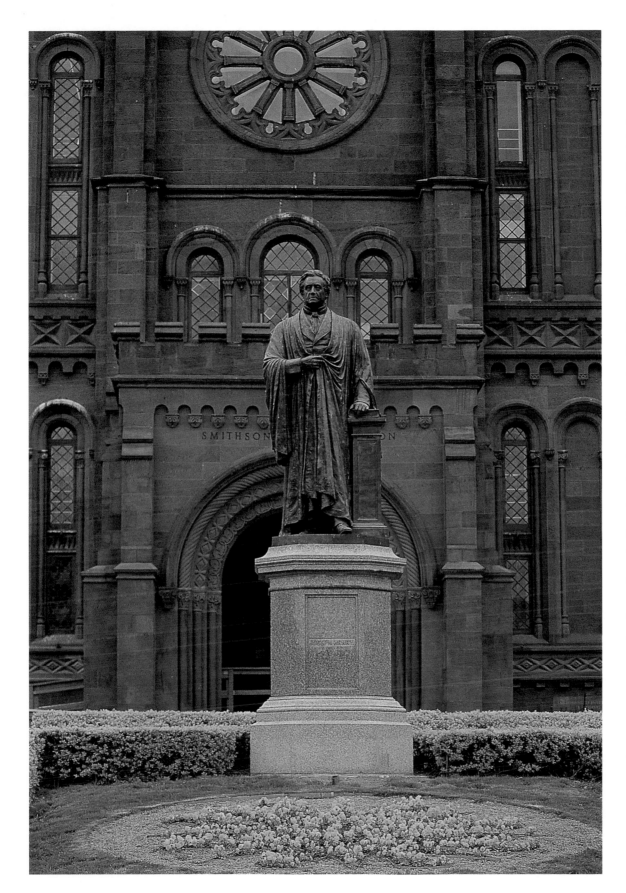

A statue of Joseph Henry, nineteenth-century physicist, stands before the Smithsonian Institution Building. Considered one of America's greatest scientists, Henry served as the first secretary of the Smithsonian from 1846 until his death in 1878.

FACING PAGE— In 1829, for reasons that remain a mystery, an English scientist named James Smithson left his fortune to the people of the United States. Today, his legacy exists in the form of 16 museums, four research centers, and several other organizations, all under the umbrella of the Smithsonian Institution.

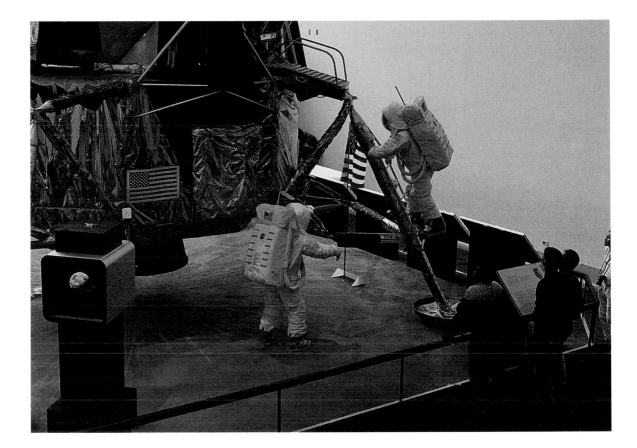

Visitors explore the history of flying, from the early attempts of the Wright Brothers to the Apollo 13 mission, at the National Air and Space Museum. With the largest air and spacecraft collection in the world, the museum offers a fascinating showcase of the effects of flight on our history.

Part of the Smithsonian Institution, the Hirshorn Museum and Sculpture Garden displays gifts from countless donors, including about 12,000 pieces from the personal collections of Joseph H. Hirshorn, who died in 1981.

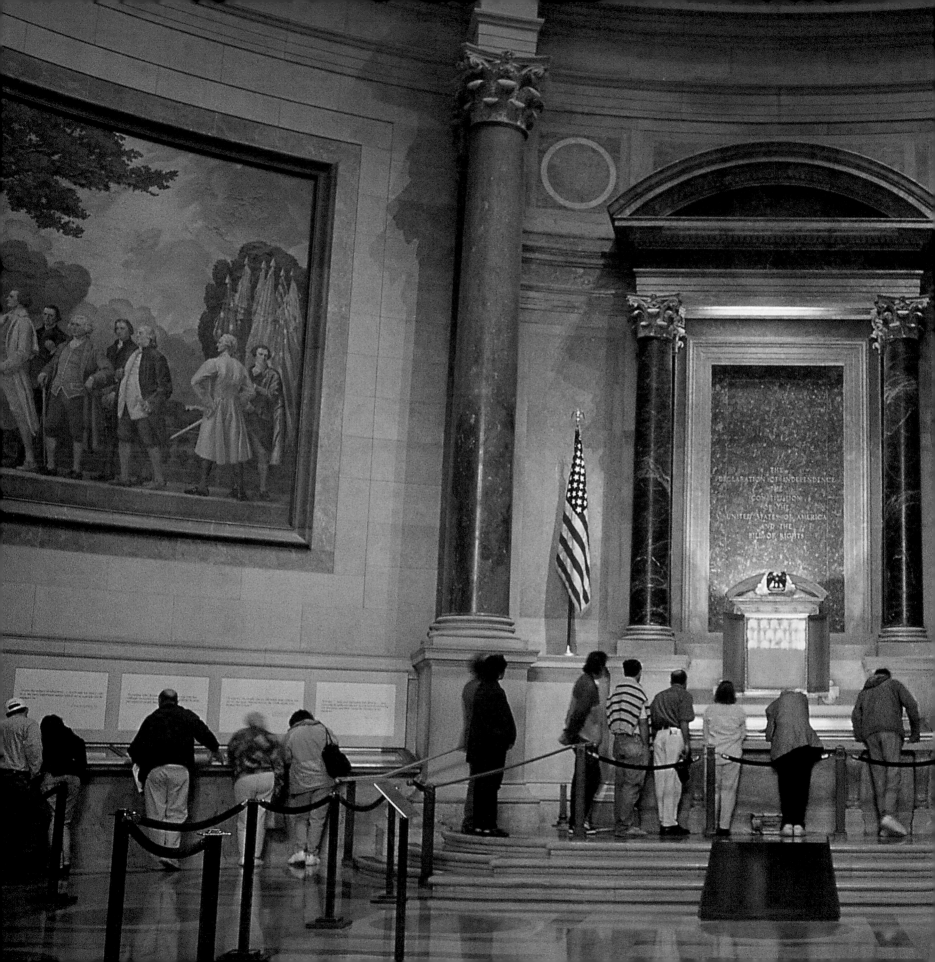

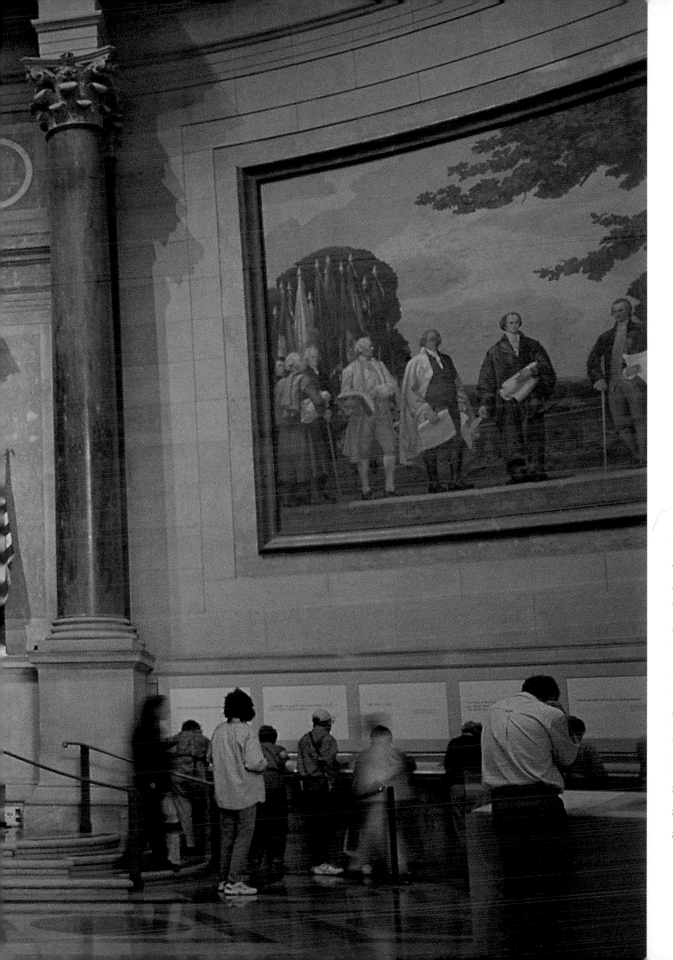

Enshrined in the National Archives and Records Administration Building, visitors will find the original Declaration of Independence, Constitution, and Bill of Rights. In total, the U.S. archives hold more than 4 billion pieces of paper, 300,000 film reels, 200,000 sound and video recordings, and 23 million photos and posters.

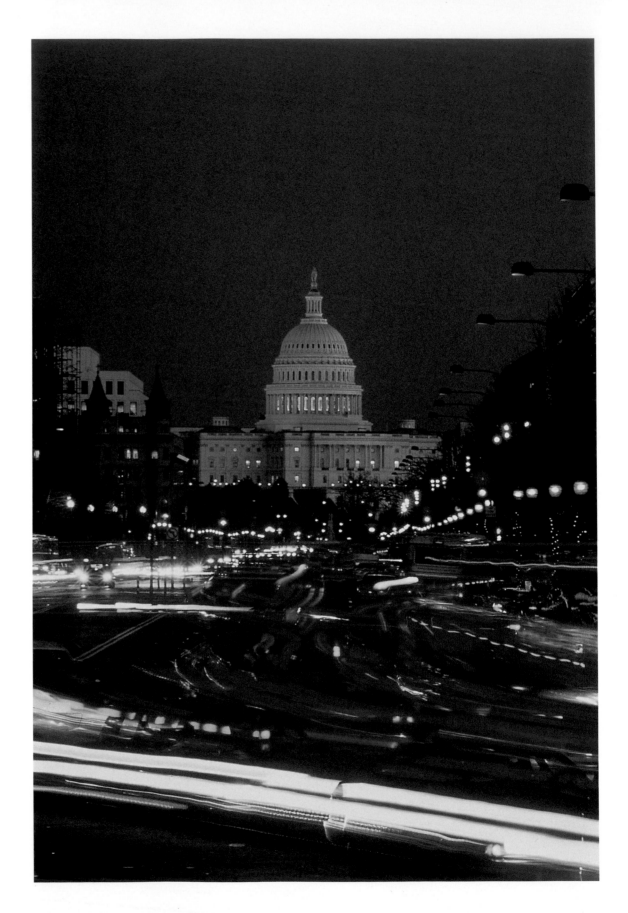

Nicknamed Avenue of the Presidents and America's Main Street, Pennsylvania Avenue links the Capitol with the White House. A major commuter route, the avenue has also hosted parades, protest marches, and countless motorcades.

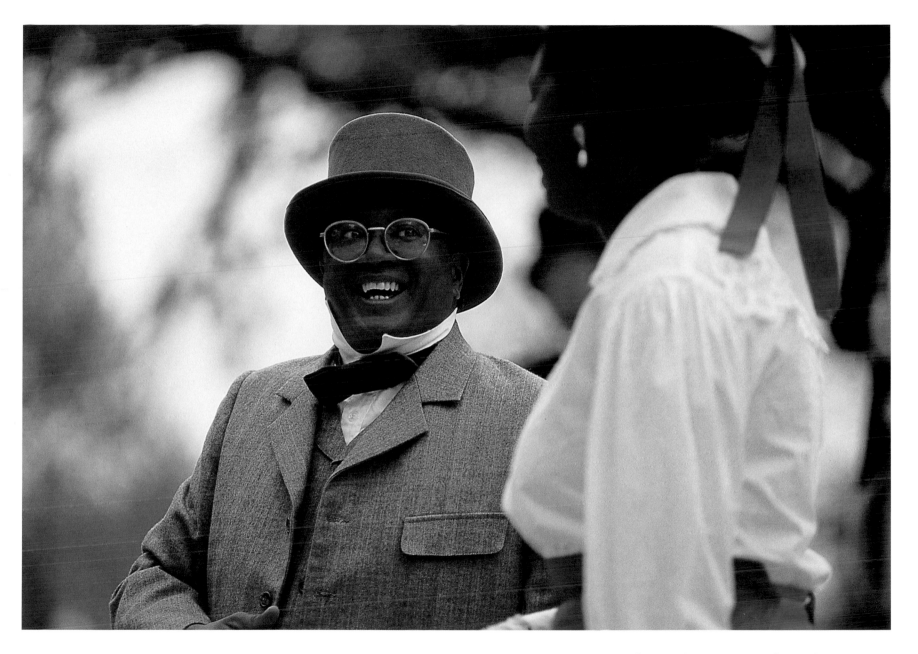

Actors on Pennsylvania Avenue help bring history to life with skits about the American Revolution, the Civil War, and more. The actors also reveal fascinating facts about the history of the city, which earned its name when locals started calling it "the city of George Washington."

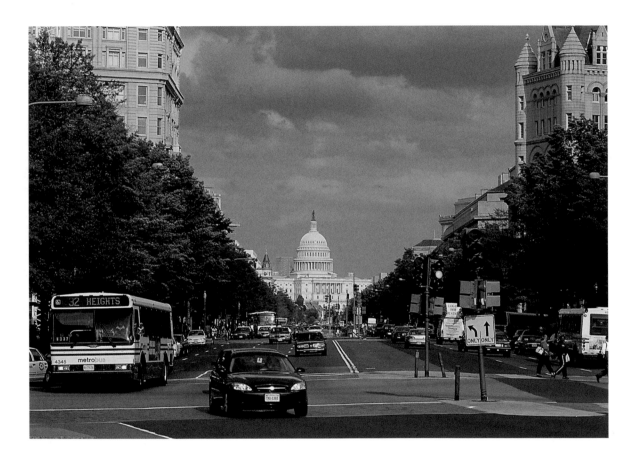

Pennsylvania Avenue was proposed by French engineer Pierre L'Enfant, who planned the original city. Some historians believe that the avenue was named to appease Pennsylvania when the seat of government was moved from Philadelphia to its present site.

Manuscripts and books, photographs and sheet music— the Library of Congress holds 119 million items, including the personal collections of Thomas Jefferson and one of the world's few perfect copies of the Gutenberg Bible.

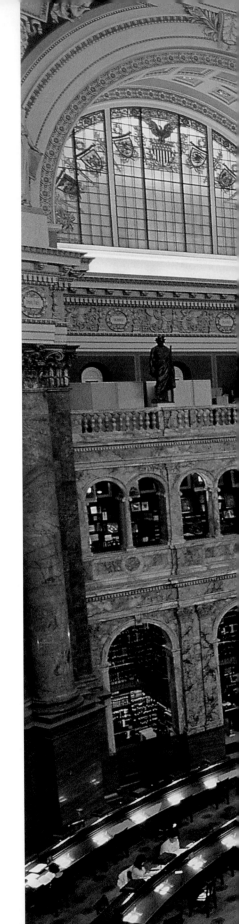

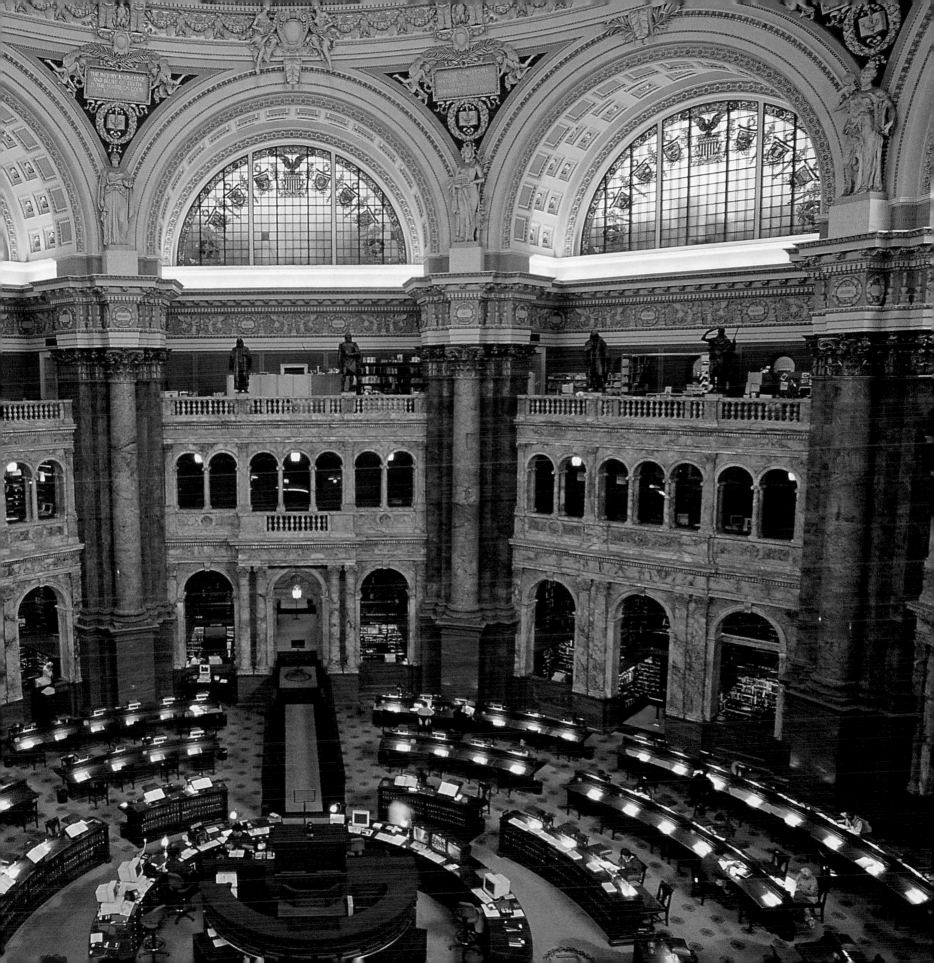

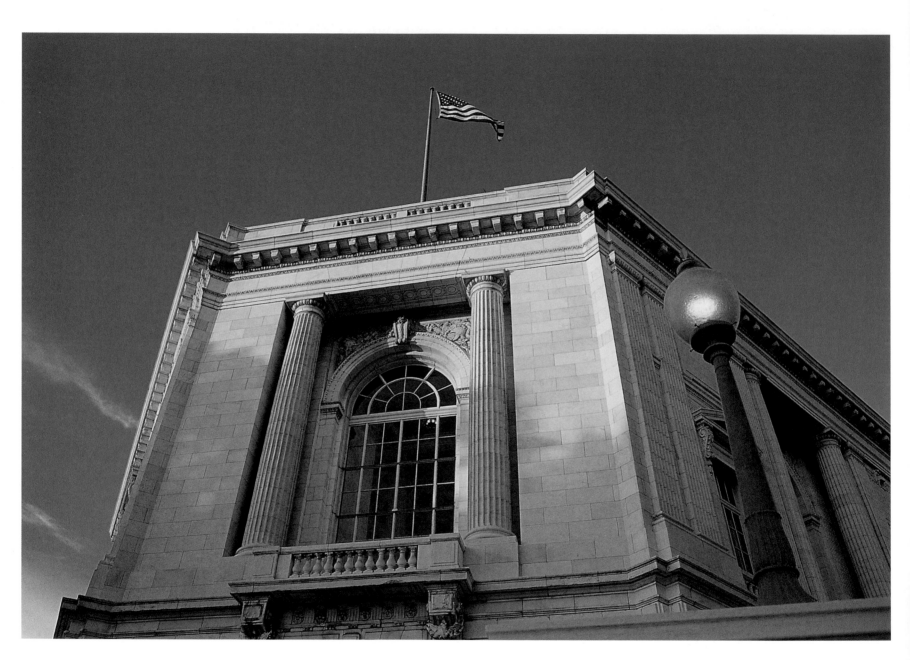

Caring for the historic buildings and green spaces of the nation's capital is the mission of National Capital Parks–Central. The organization maintains more than 80 buildings, 150 parks and public spaces, 170 flower beds, and 35 pools and fountains.

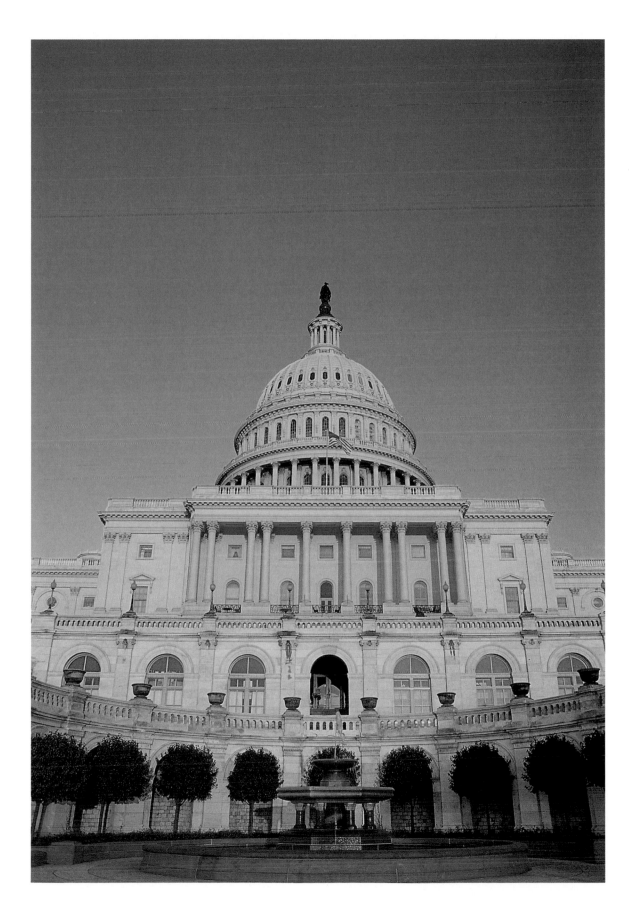

The United States Capitol Building stands atop Capitol Hill, visible throughout the city. George Washington laid the building's cornerstone in 1793. It was finally completed in 1830, only to be expanded and renovated in the 1850s.

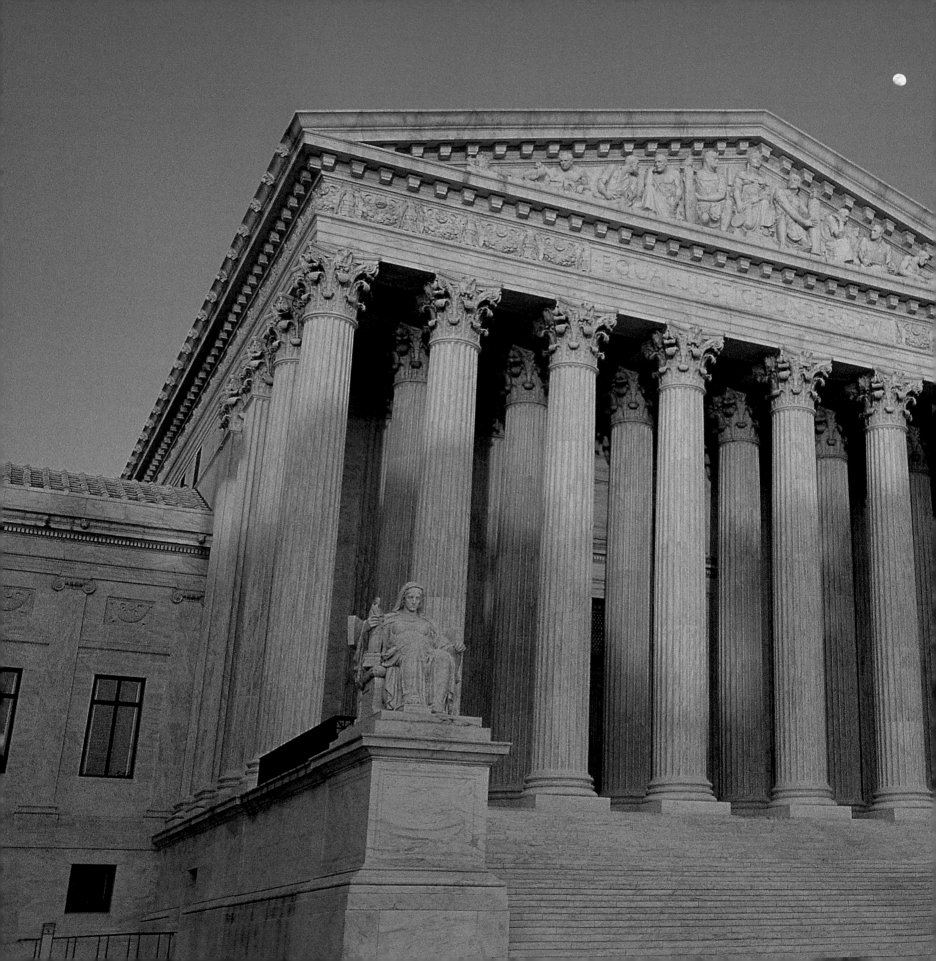

The gleaming white marble of the Supreme Court stands opposite the Capitol. Here, the nation's highest judicial body has debated some of the century's most controversial issues, including whether African Americans should hold citizenship and whether women have the right to abortions.

49

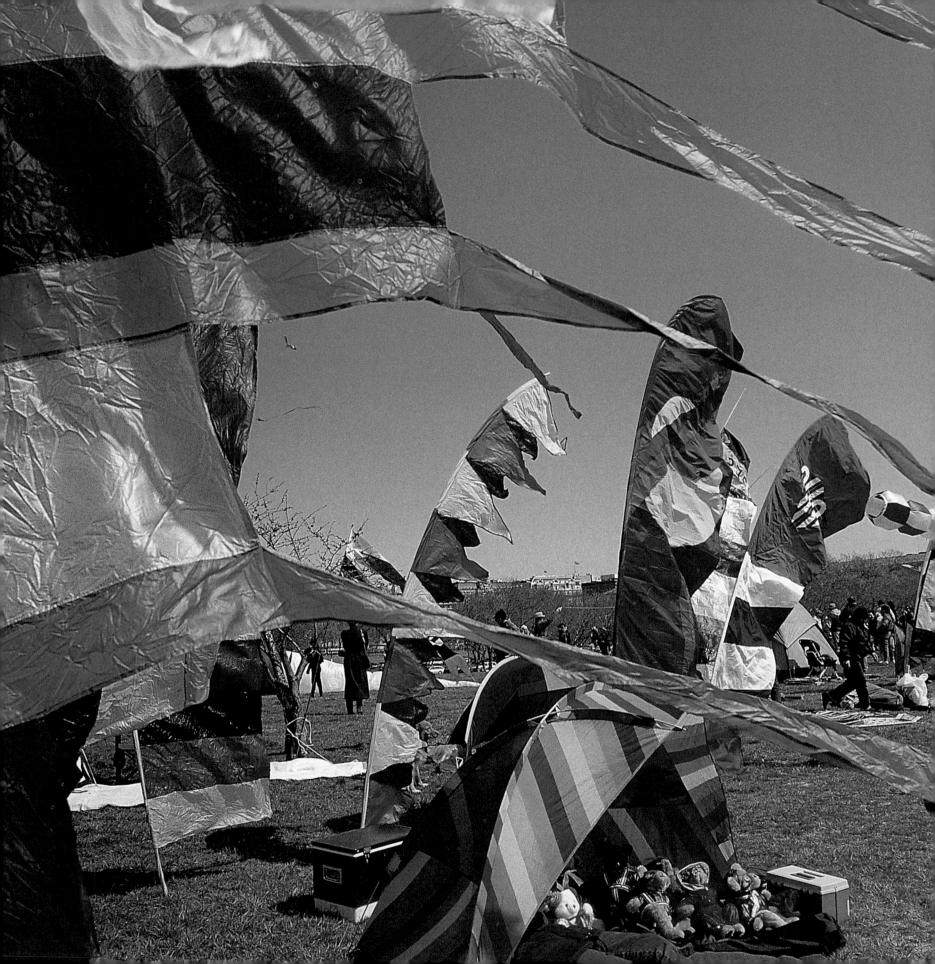

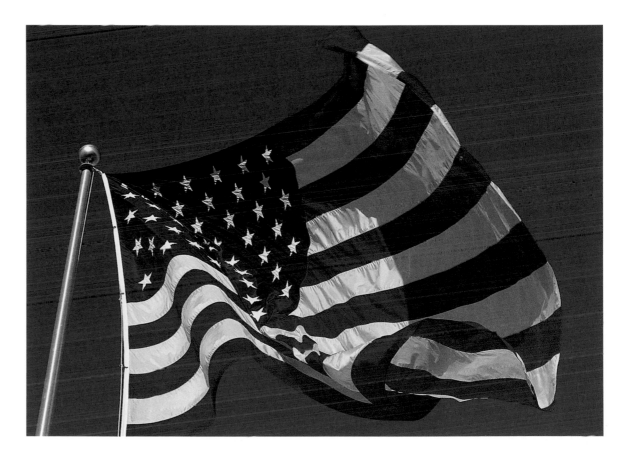

Congressman Francis Hopkinson designed the first American flag, sewn by seamstress Betsy Ross. Today's flag bears 13 stripes to represent the original 13 colonies and 50 stars to symbolize the 50 states.

From homemade masterpieces to state-of-the-art stunt kites, the Smithsonian Kite Festival brings out the region's best and brightest flyers. This institute has held contests and displays each spring for more than 30 years.

51

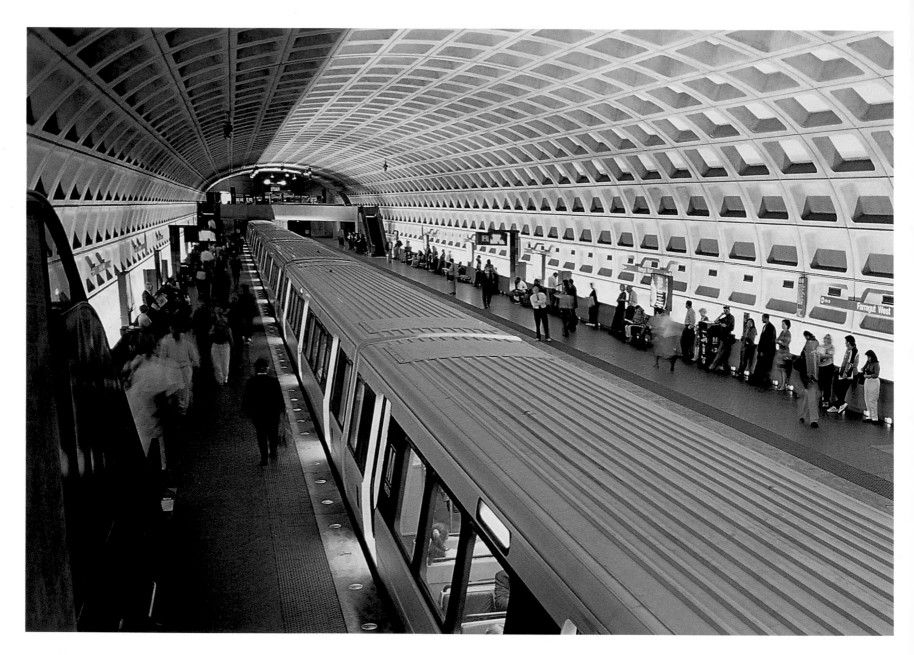

Washington's public transit service extends over 1,500 square miles. More than 750 train cars and 1,300 buses transport people around the city.

Displays and exhibits at the historic home of Alice Paul reveal the history of the National Woman's Party. Paul founded the party in 1916, leading the fight for suffrage and equality. She authored the Equal Rights Amendment to the Constitution in 1923.

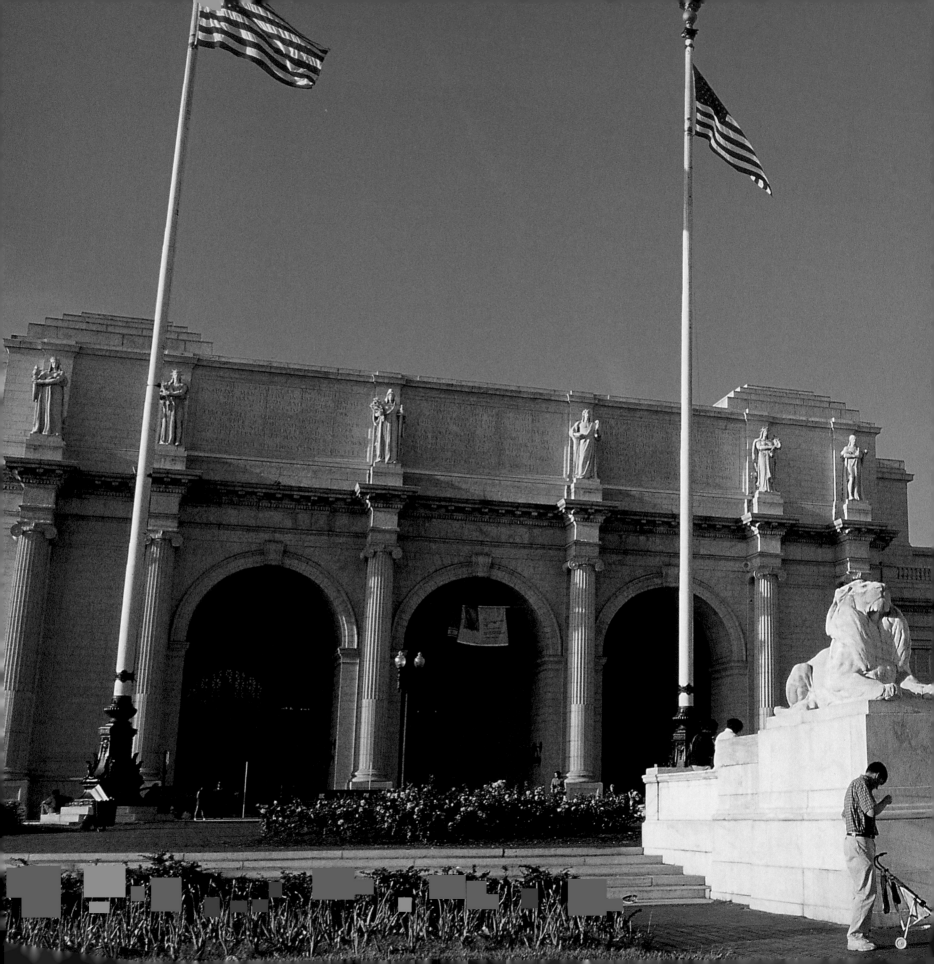

More than 23 million people a year cross the marble floors of Union Station—the most visited place in Washington. When it was built in 1908, it was the largest train station in the world.

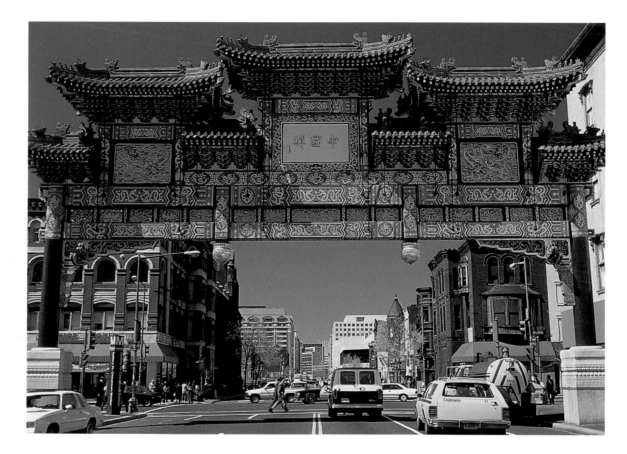

This vibrant arch welcomes visitors to Washington's Chinatown. Decorated with more than 270 intricately painted dragons, the arch is the center of activities during the annual Chinese New Year celebrations.

On April 14, 1865, actor John Wilkes Booth shot President Abraham Lincoln during a performance at Ford's Theatre. Booth escaped, only to be killed 12 days later when he refused to surrender to Union troops. Now a national historic site, Ford's Theatre houses a Lincoln museum.

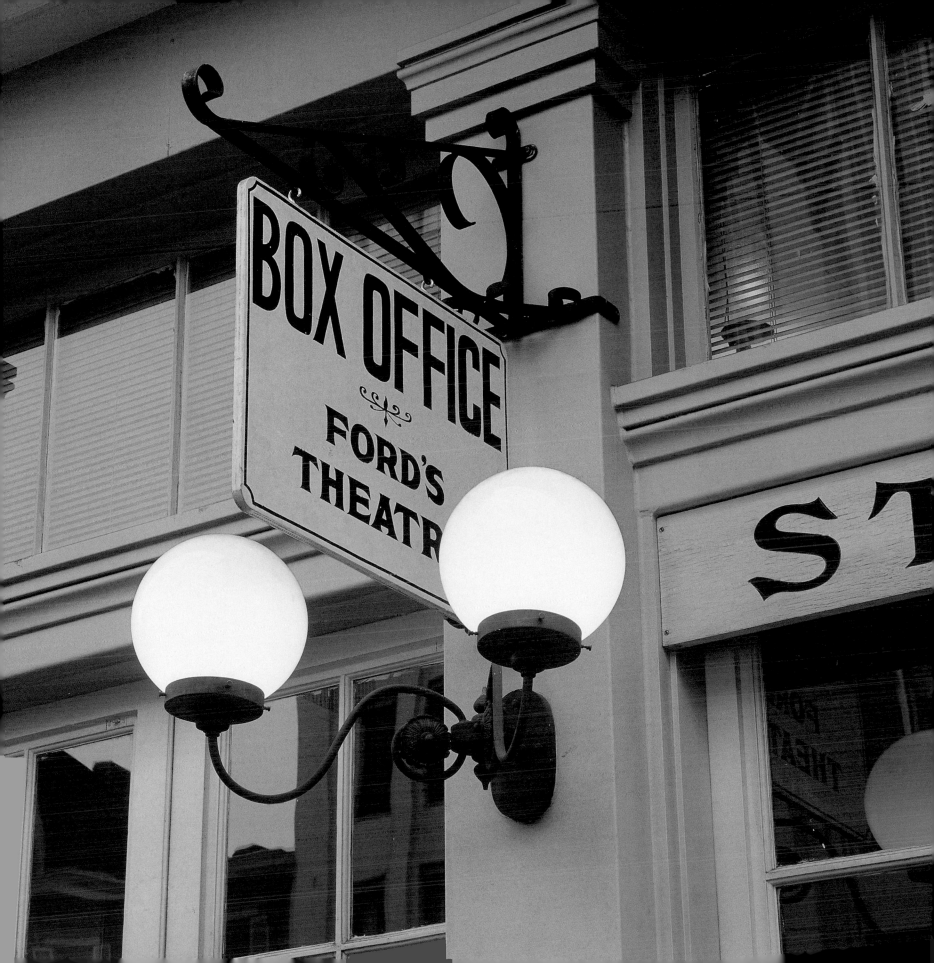

Distinct neighbor-
hoods surround
downtown Wash-
ington. From the
row houses of Foggy
Bottom to the posh
enclaves of Dupont
Circle, each offers
its own charm and
character.

58

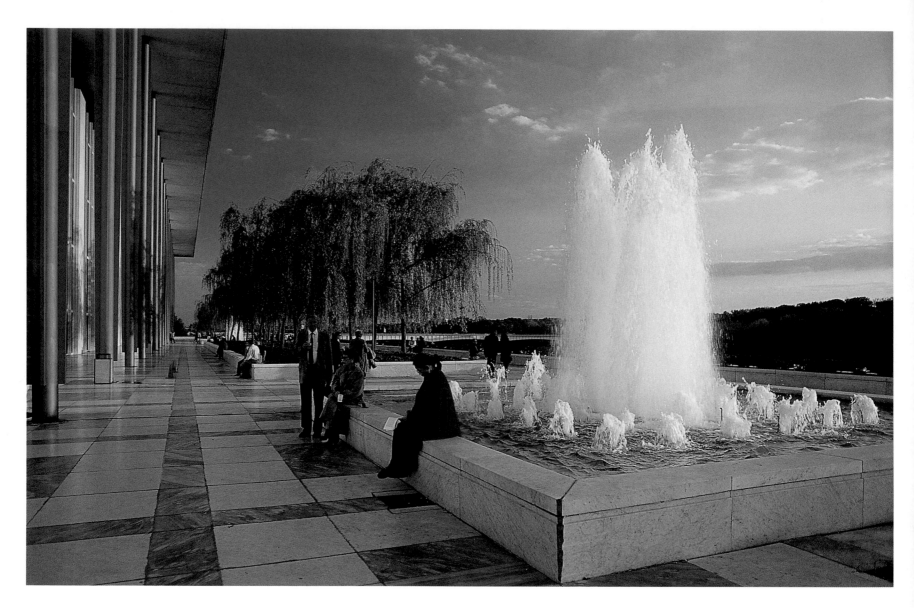

Designed by Edward Durrell Stone and dedicated to President John
F. Kennedy in 1971, the Kennedy Center includes five distinct theaters,
which serve as venues for stage plays, operas, ballets, symphonies,
experimental drama, children's events, and more.

When George Washington saw the Potomac River, he envisioned a
shipping route to carry the resources of the Ohio Valley to markets
around the world. He spearheaded the construction of locks,
dredging of the channel, and the creation of skirting canals, but
the improvements were still incomplete when he died in 1799.

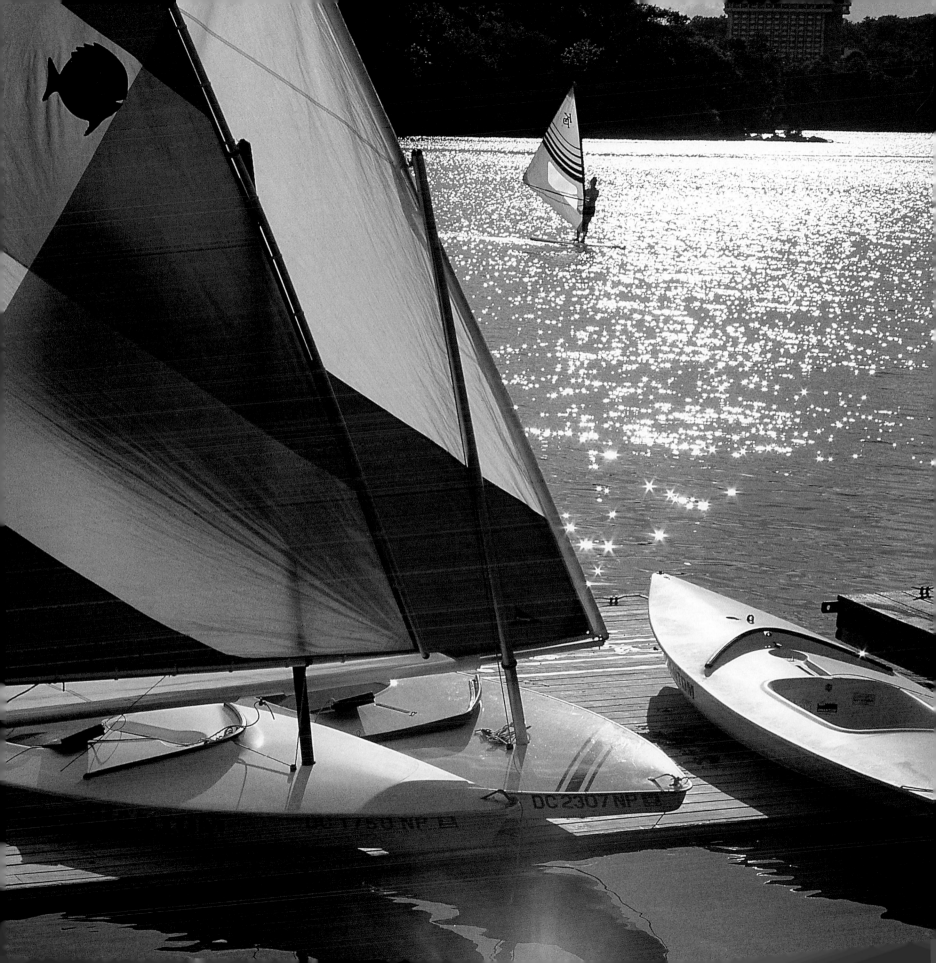

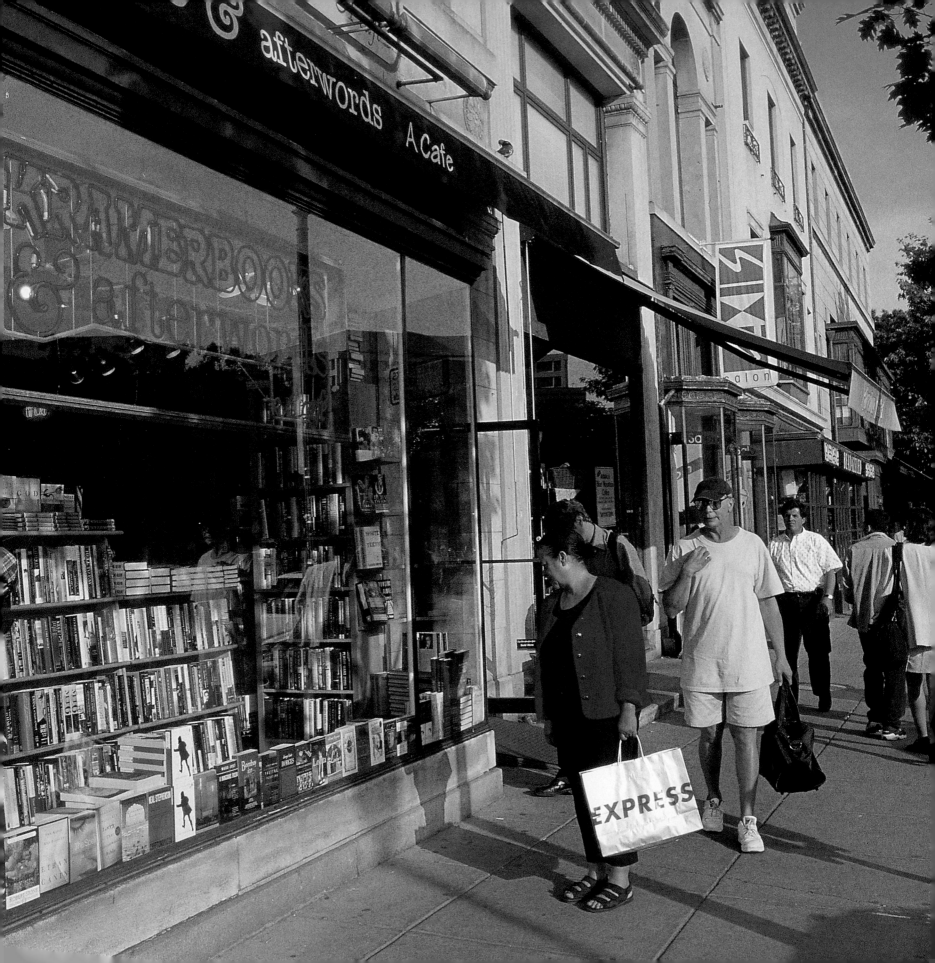

The arrest of five burglars on June 17, 1972, at the Democratic National Committee headquarters in the Watergate Building, sparked a two-year investigation. Ultimately, inquiries pointed to the involvement of President Richard Nixon, who, in 1974, became the first president ever to resign.

Cafés and embassies, art galleries and historic homes—lively Dupont Circle offers something for everyone. Sushi bars and wine stores are landmarks for the after work crowds, while specialty garden and home-decor shops draw buyers from across the city.

Nature lovers can cycle an 11-mile path along scenic Rock Creek from the Lincoln Memorial to the border of Maryland. Though it runs through the heart of the city, Rock Creek Park offers a peaceful retreat, with bird watching opportunities and 15 miles of hiking trails.

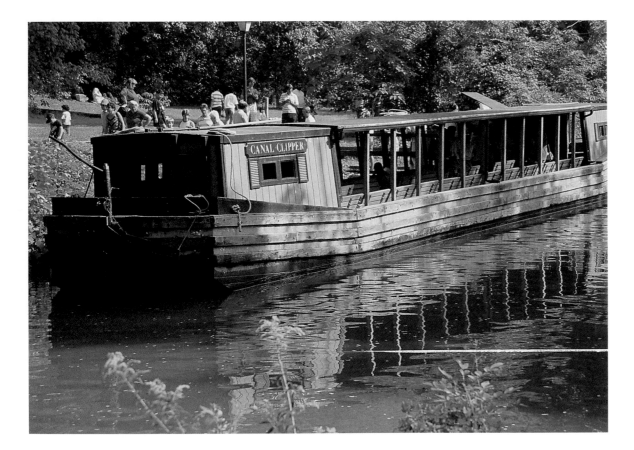

The Chesapeake and Ohio Canal was an attempt to link the Ohio River with shipping routes, after improvements to the Potomac River failed. Vessels plied the canal until floods in 1889 and 1924 left it virtually impassable. More than 4,000 miles of canals were built in the nineteenth century; the C&O is the only route remaining.

Known as Embassy Row, a collection of about 70 embassies stretches from the center of Dupont Circle northwest along Massachusetts Avenue. From Belarus and Cameroon to Nepal and Slovenia, nations from around the world are represented.

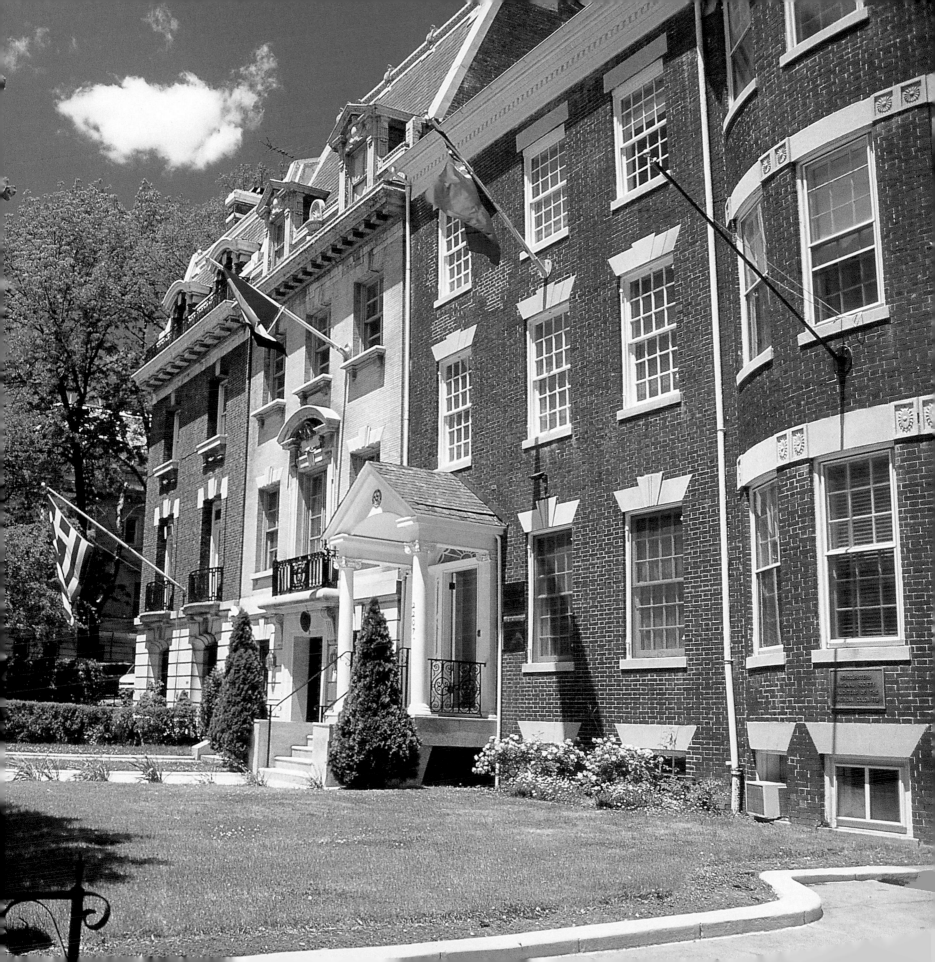

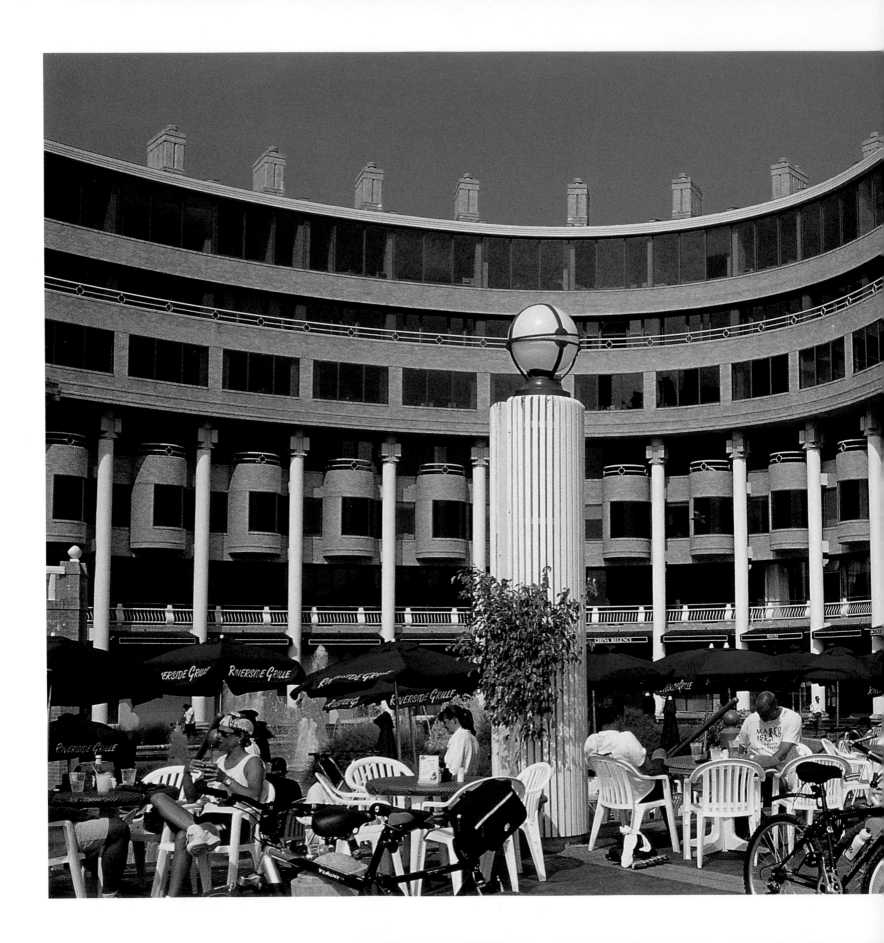

Home to native people, fur traders, then settlers, Georgetown was well established before George Washington chose the site for his new nation's capital. Today, this neighborhood is a lively mix of professionals and students.

A tobacco merchant's mansion and a ship captain's home, a safehouse on the underground railway and an impromptu hospital for Civil War soldiers—each Georgetown home is rich in history and adventure.

From Georgetown to Connecticut Avenue, Washington's upscale shopping districts draw crowds year-round.

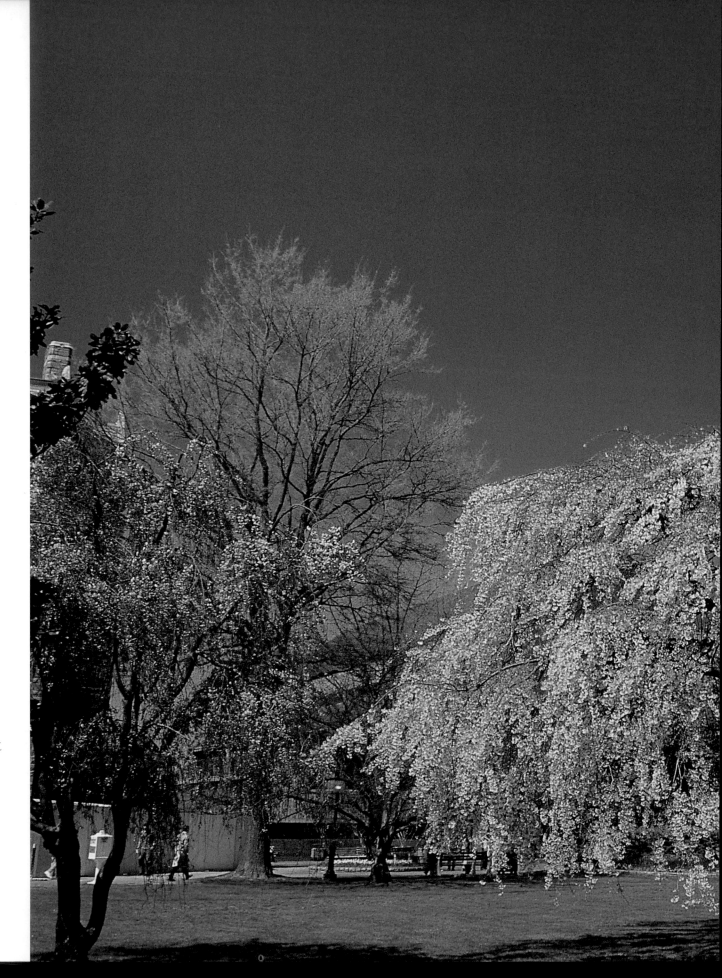

In the late 1780s, Georgetown College opened to 12 students. Today, Georgetown University is a thriving community of almost 2,000 students. The 104-acre campus includes more than 60 buildings and a teaching hospital.

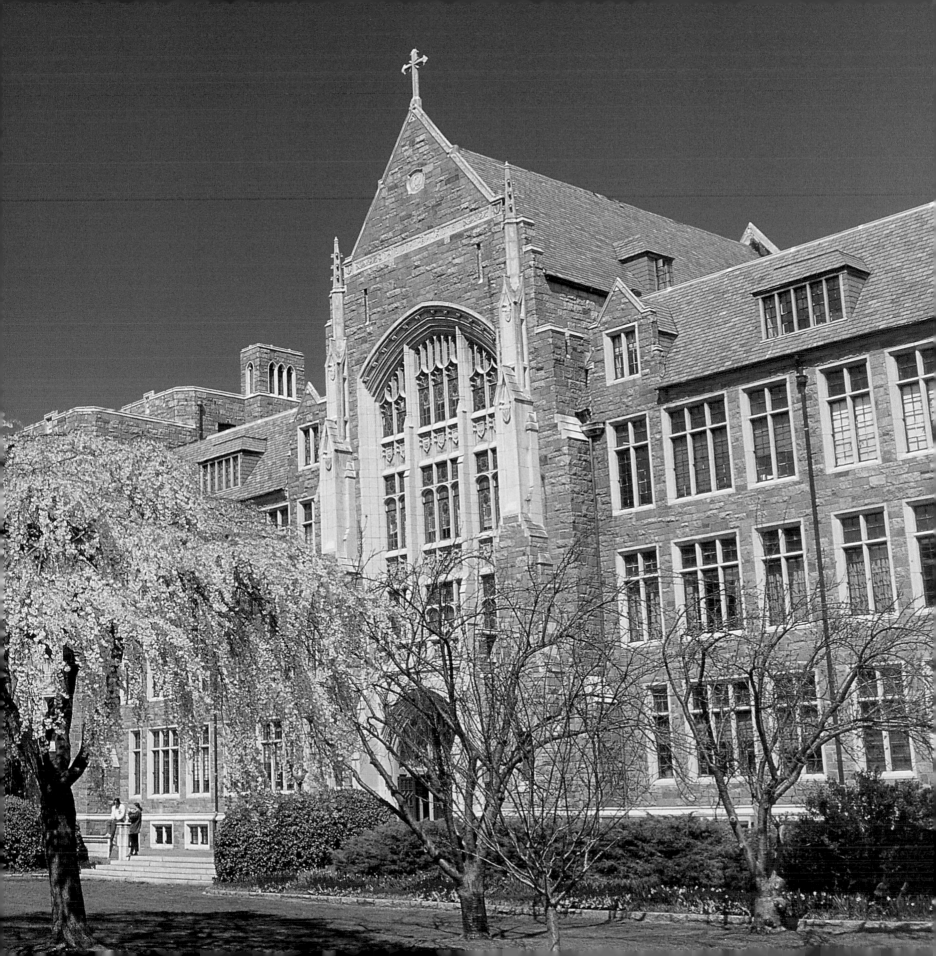

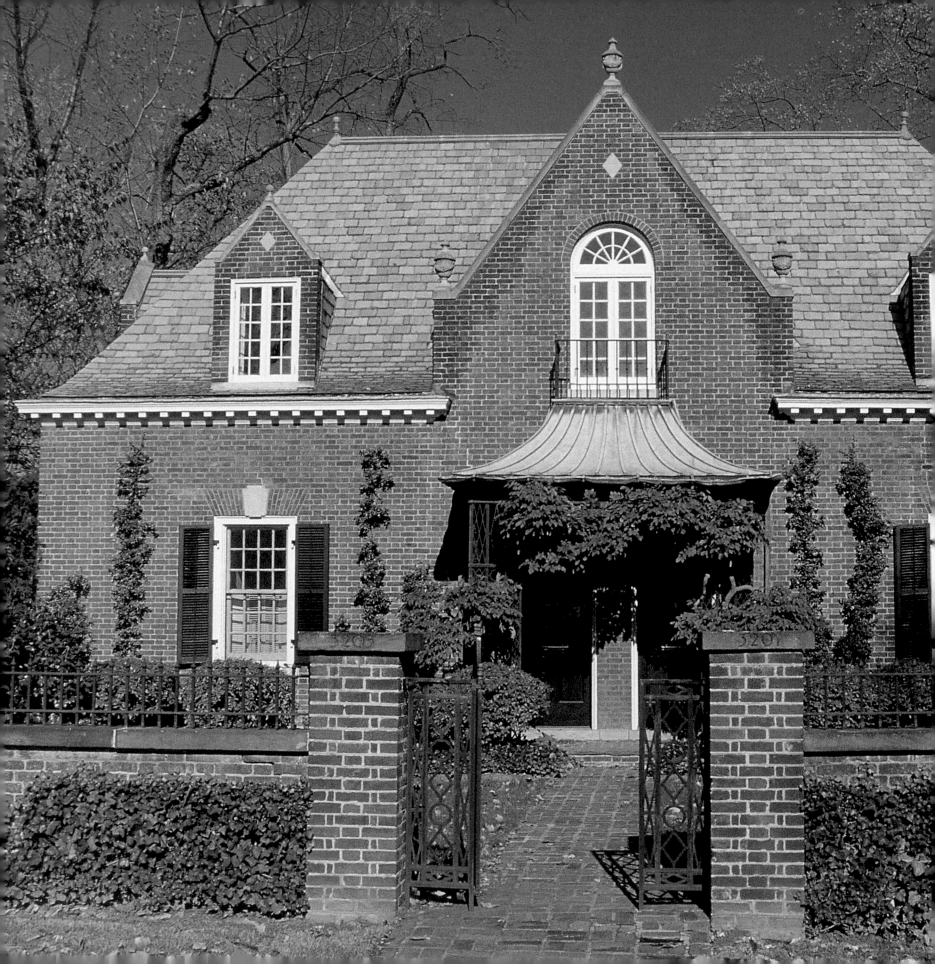

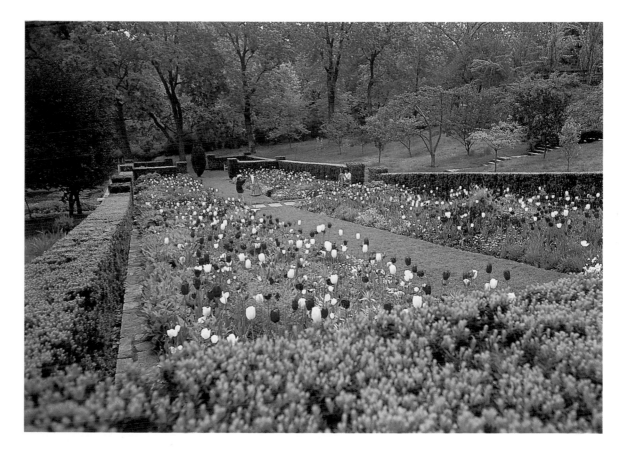

Some of the original oaks which lent Dumbarton Oaks its name still stand in the site's 16-acre gardens. They shelter rose and vegetable gardens, a grape arbor, a reflecting pool, an orchid house, and more.

Mildred and Robert Woods Bliss bequeathed their Dumbarton Oaks home and gardens to Harvard University in 1940. Four years later, government representatives met here and agreed to form the United Nations.

Standing on Washington's highest point, the National Cathedral towers 676 feet above sea level—higher than the Washington Monument. The first stone was laid here in 1907; the final in 1990. Every president since Theodore Roosevelt has visited or attended services at the cathedral.

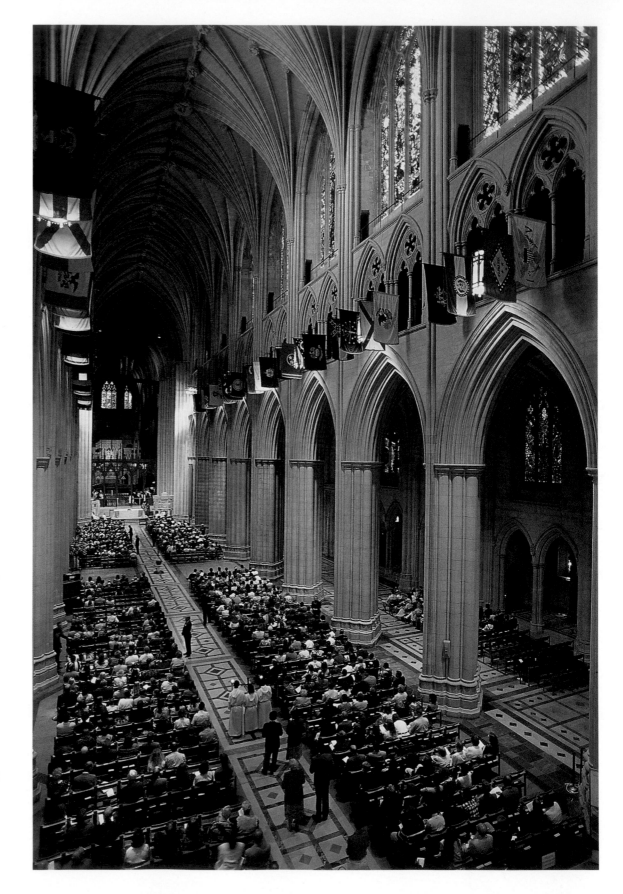

Set on 446 acres dotted with groves of native deciduous trees, the National Arboretum includes a herb garden, an extensive bonsai museum, a garden containing specimens of the flora of every state, and much, much more. Visitors can meander through a valley of plants native to China or visit a collection of North American native plants, many with ancient medicinal uses.

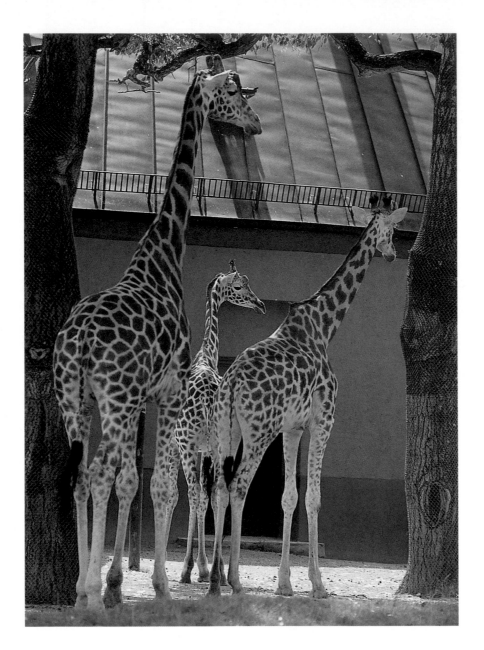

The Smithsonian National Zoological Park is home to about 500 animal species, and a total of 5,800 creatures.

Designed by Frederick Law Olmsted, the 163-acre Smithsonian National Zoological Park was established specifically to save animals from extinction. Interpreters offer insight into animal behavior, and there are even hands-on exhibits in the reptile house.

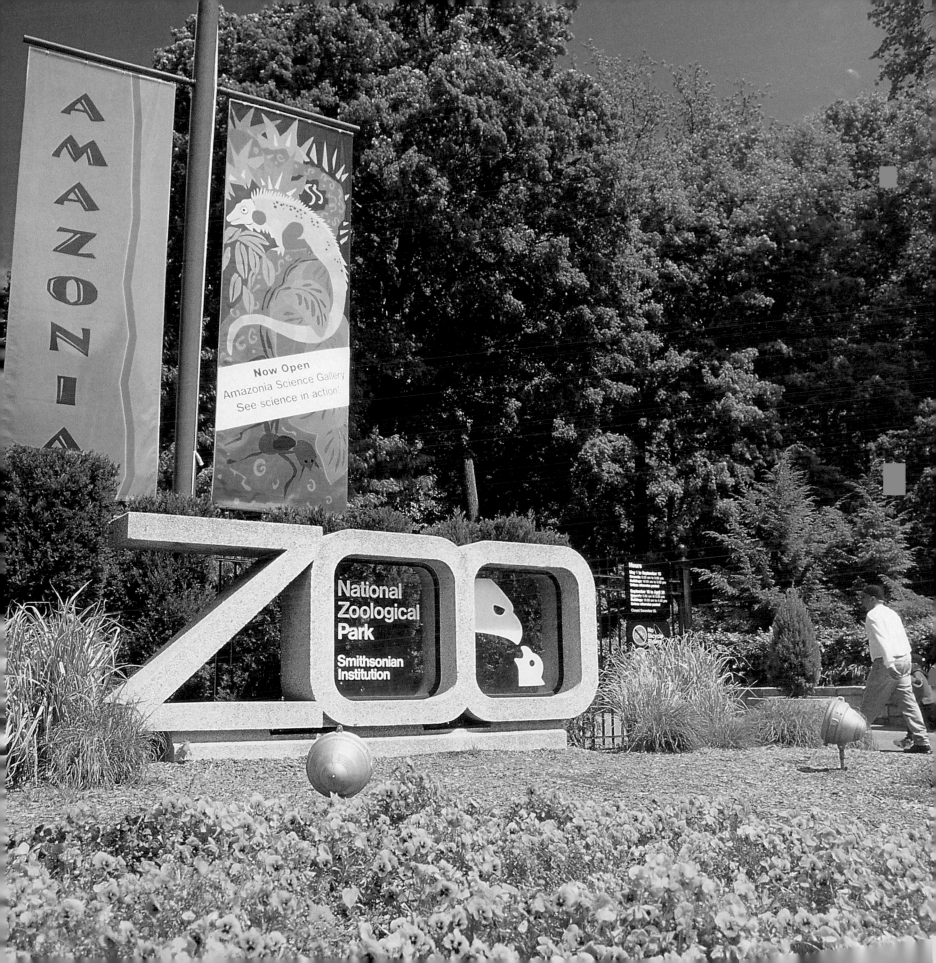

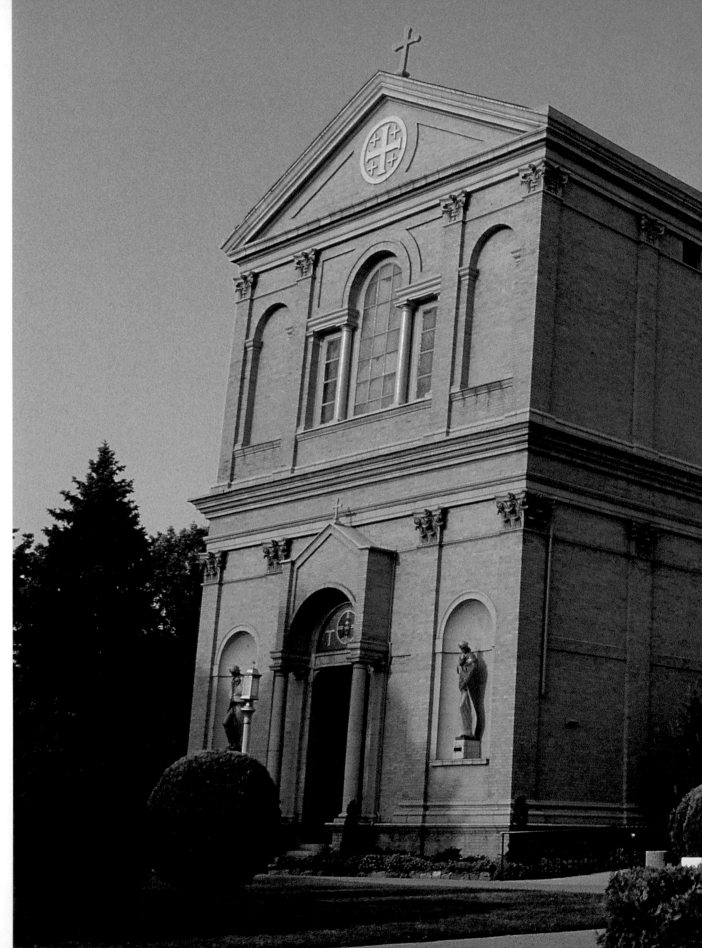

The Order of St. Francis is dedicated to maintaining Roman Catholic holy sites around the world and caring for those who live in the Holy Land. The Franciscan Monastery in Washington trains priests and brothers and raises funds to help accomplish these goals.

ST. CHRISTOPHER
WHO FOR THE LOVE
OF GOD ASSISTED
WAYFARERS ACROSS A
STREAM HAS BECAUSE
OF HIS CHARITY BEEN
INVOKED BY MANY AS
THE PATRON SAINT OF
THOSE WHO TRAVEL
BY AVTOMOBILE

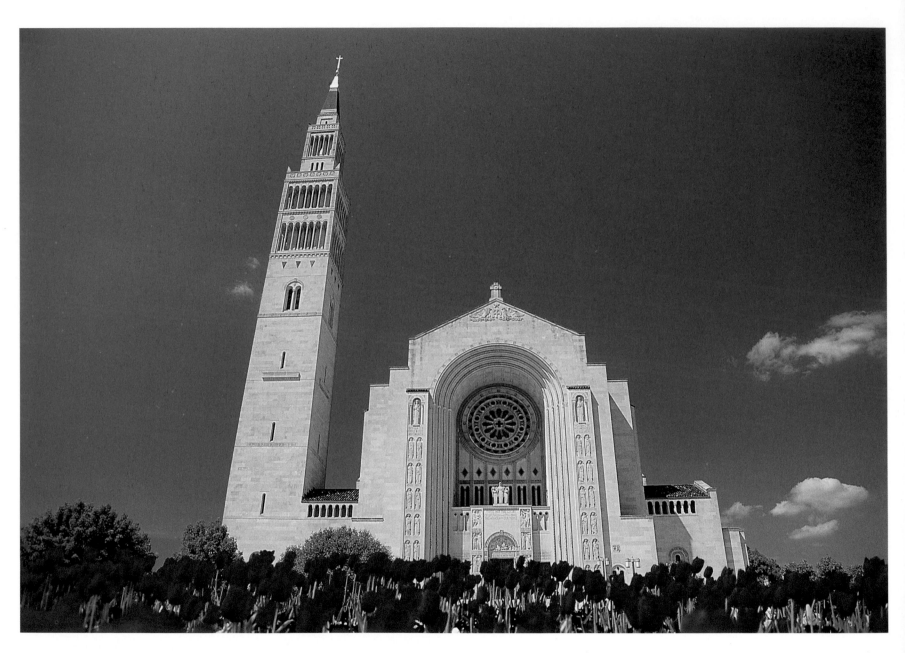

Within the National Shrine of the Immaculate Conception, 60 chapels and oratories depict the history of Catholicism in America, from the arrival of the first European immigrants to the pilgrims who tour the shrine today.

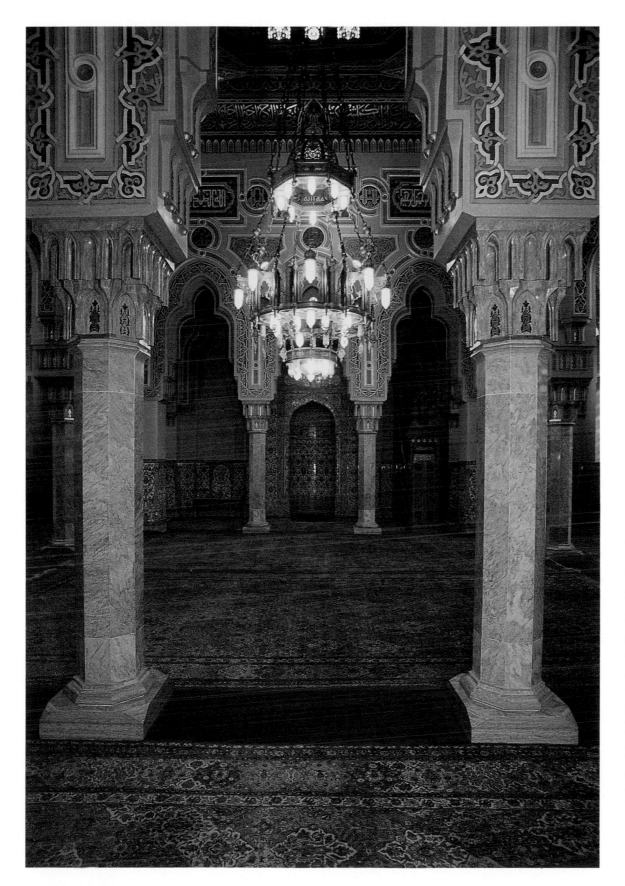

The ornate interior of Washington's mosque is rivaled only by the building's towering exterior. Washington is also home to the Center for the Study of Islam and Democracy, a think tank dedicated to studying Islam and politics.

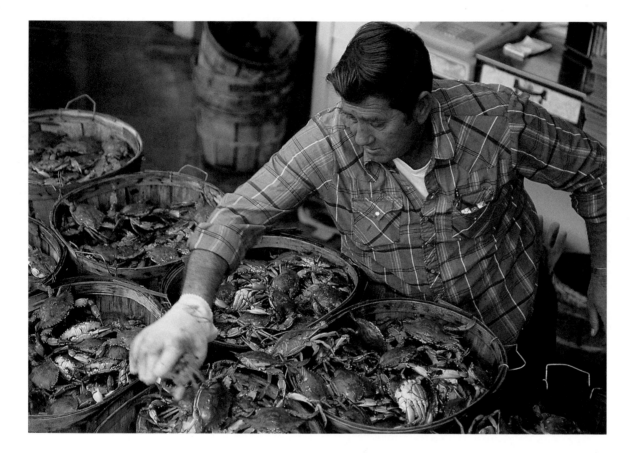

A fish vendor offers the day's catch. At some local eateries, servers provide shellfish, crab crackers, and bibs, and the patrons do the rest.

The region is famous for fresh fish and shellfish. Enthusiasts seek the local markets for the best buys, or savor crab cakes—a regional specialty—in one of the many seafood restaurants.

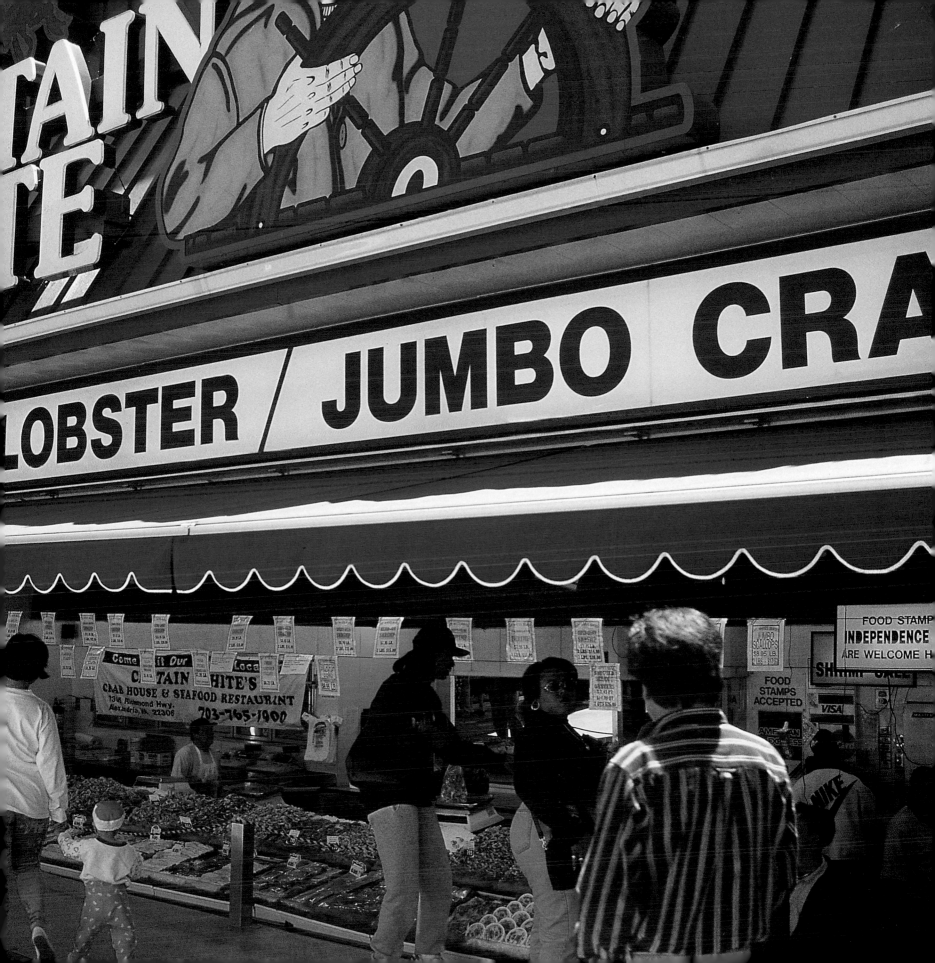

The Marine Corps War Memorial commemorates the service of the U.S. Marine Corps. It stands on the scenic George Washington Memorial Parkway along the Potomac River.

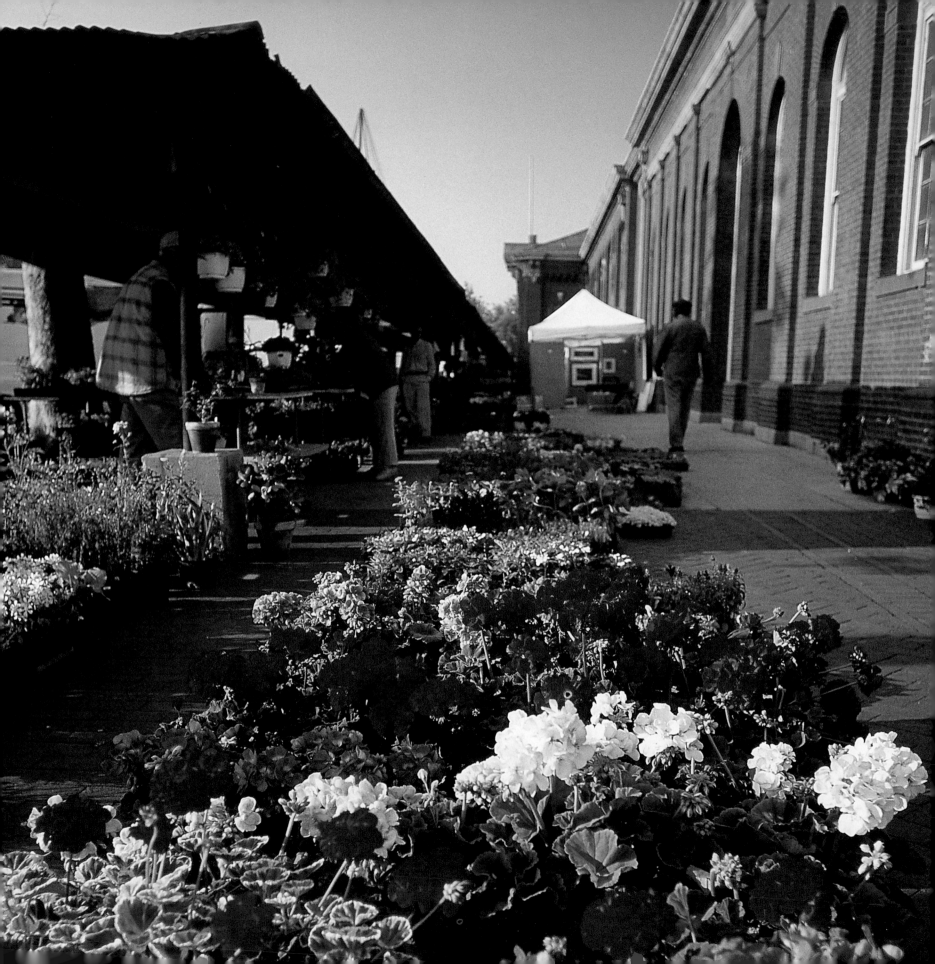

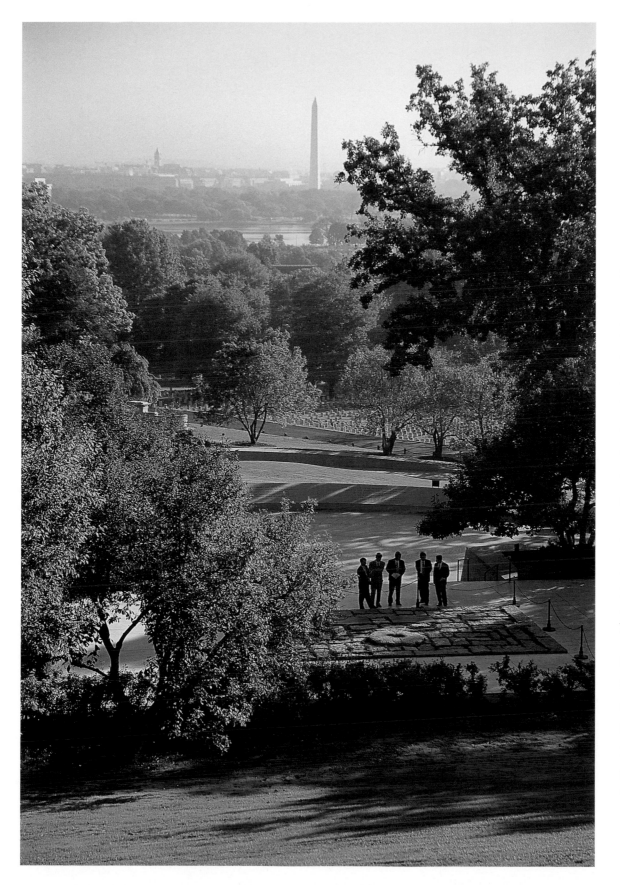

On 612 acres, the Arlington National Cemetery holds the graves of John F. Kennedy and Robert Kennedy, as well as the Tomb of the Unknowns, where the bodies of unnamed soldiers from four wars lie at rest.

FACING PAGE—At an open air market in Virginia, just south of Washington D.C., shoppers can find freshly cut flowers and the best of southern cuisine—fresh vegetables, seafood and mouth-watering desserts.

Washington's parks and preserves encompass about 90,000 acres, making it one of the greenest cities in the nation. In lush Rock Creek Park and in the surrounding districts, there are quiet bridle paths and picturesque trails designed specifically for riders.

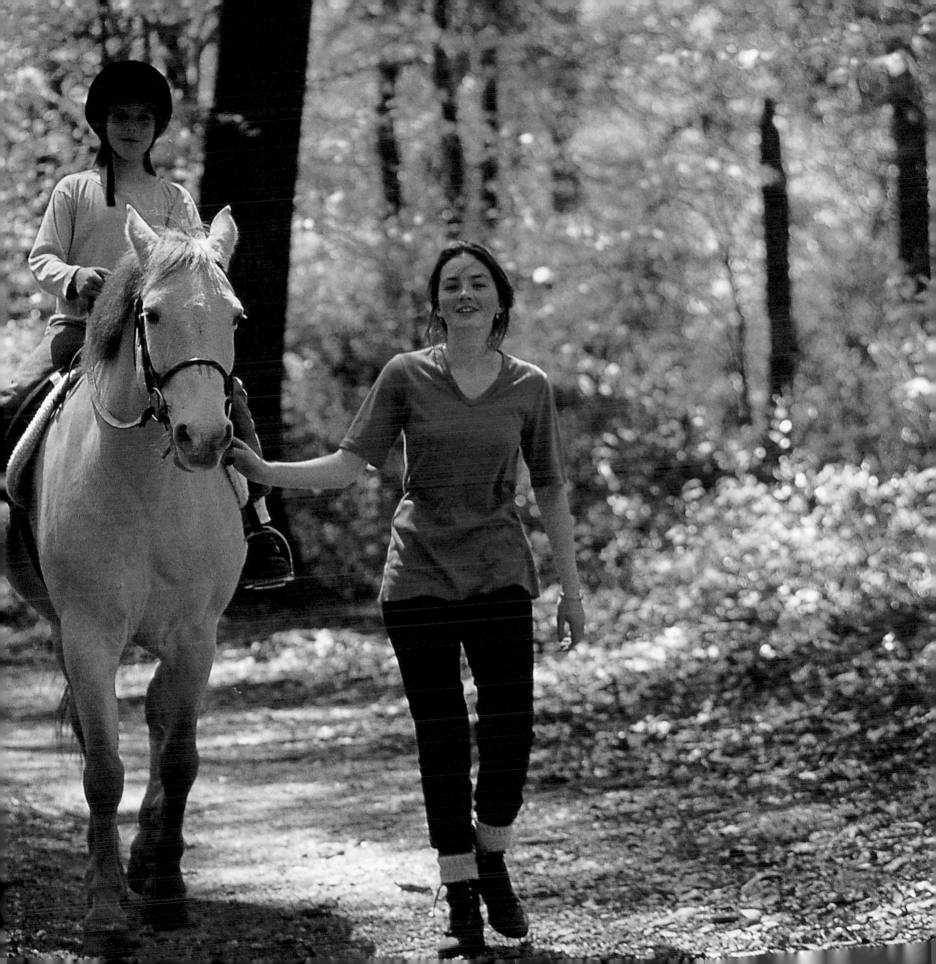

The George Washington
Masonic National Memorial
stands in Old Town
Alexandria, Virginia. Built
on the site of a Civil War
fort, the monument was
created to honor George
Washington—a member of
the freemasons—and rep-
resent the order's support
of liberty and government.

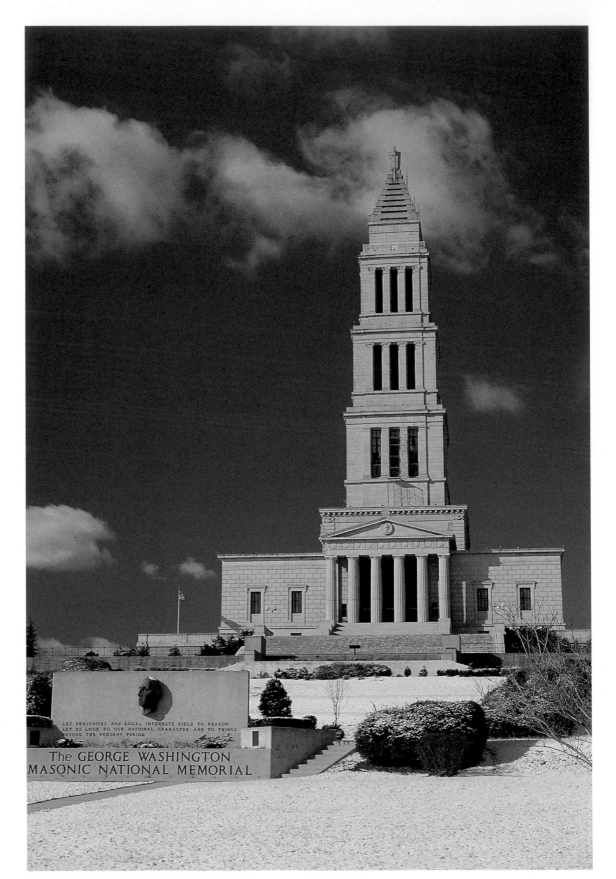

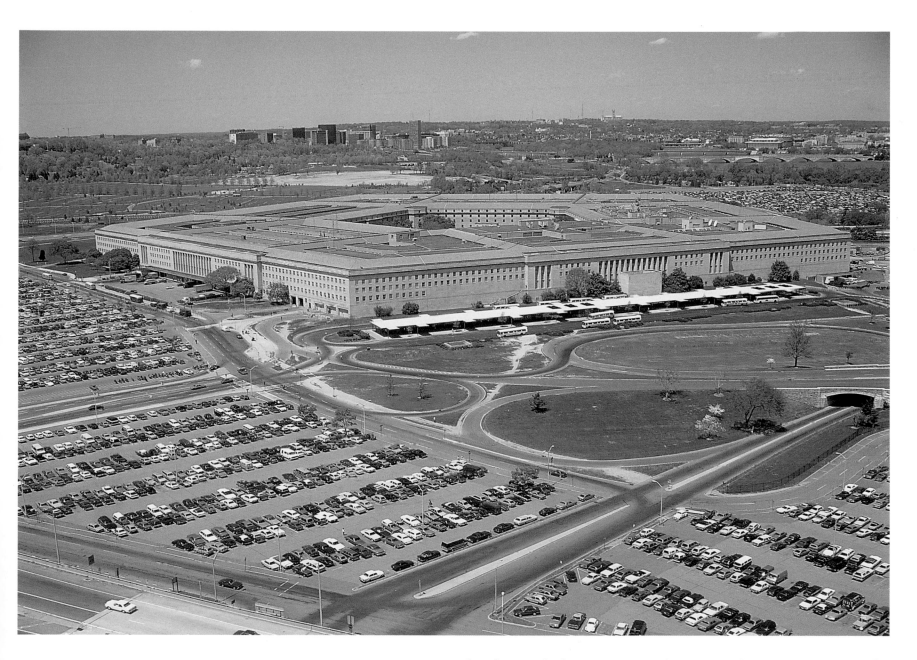

The five-sided Pentagon is home to the Department of National Defense. The enormous complex was built in a little over a year during World War II.

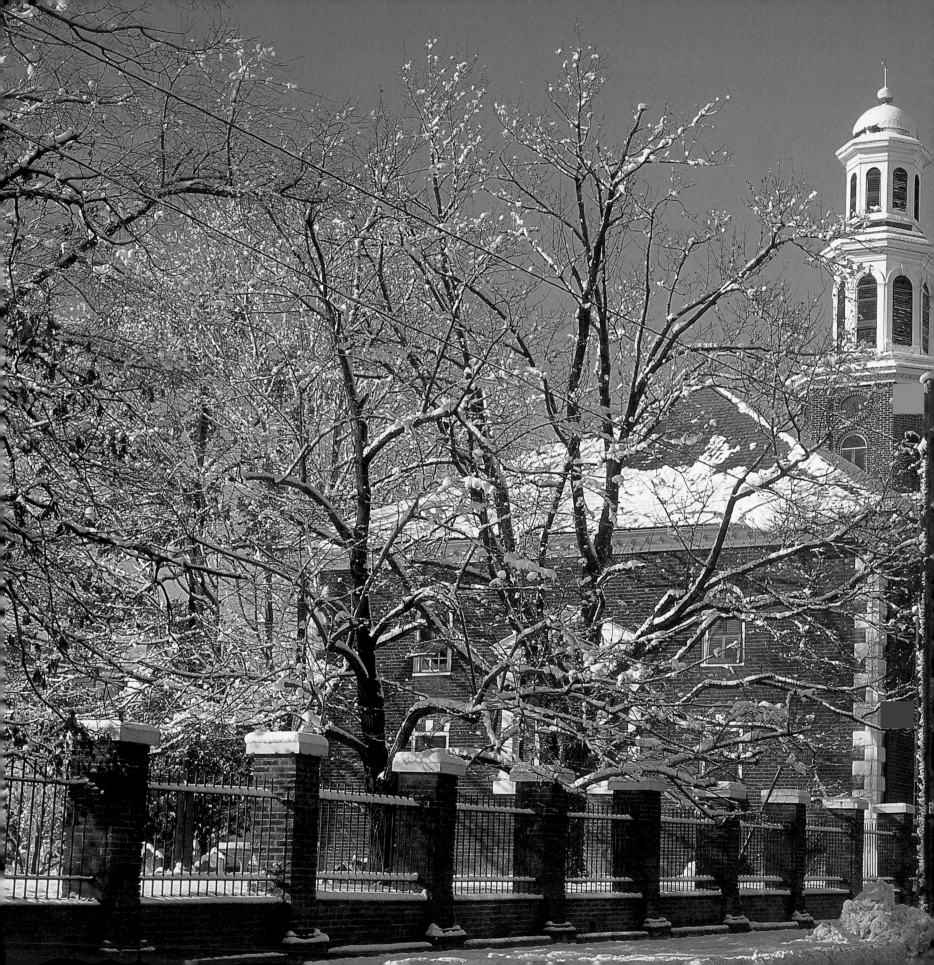

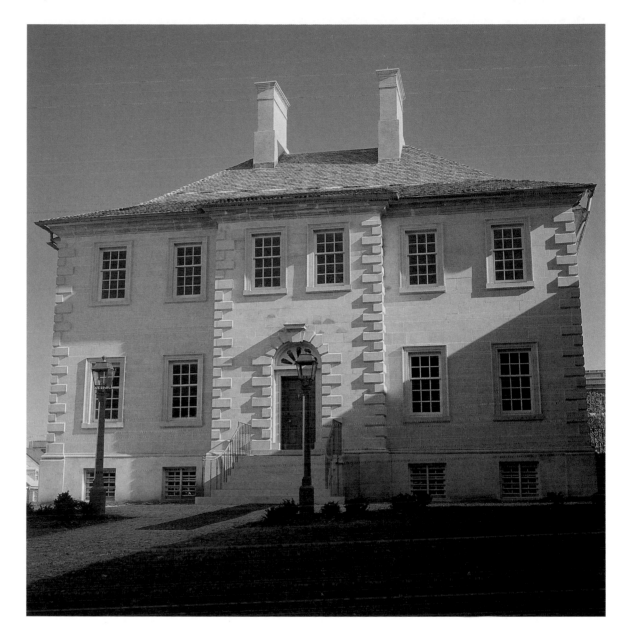

Merchant John Carlyle built Carlyle House in 1753 for his new bride. Their home became one of Alexandria's social centers. During the French and Indian War, it was used as a headquarters by British General Braddock.

George Washington once owned a pew in Alexandria's Christ Church. Built in 1773, the church ministered to soldiers during the American Revolution and the Civil War.

Photo Credits